DRAWING
ideas, materials
and techniques

Revised Edition

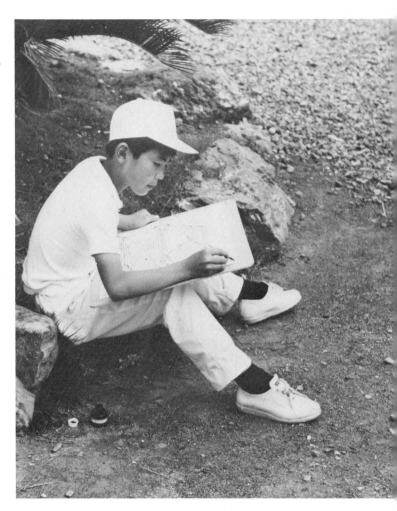

GERALD F. BROMMER
Lutheran High School, Los Angeles, California

DAVIS PUBLICATIONS, INC.
Worcester, Massachusetts

HENDRICK-LONG PUBLISHING COMPANY
Dallas, Texas

DRAWING
IDEAS, MATERIALS
and TECHNIQUES

REVISED EDITION

To my mother and father,
who put the first pencil
into my hand.

Copyright 1978. All rights reserved.
Davis Publications, Inc.
Worcester, Massachusetts, U.S.A.
Printed in the United States of America
Library of Congress Catalog Card Number: 78-59861
ISBN: 0-87192-099-9
Printing: Alpine Press
Type: 9/11 point Optima
Graphic Design by the Author and Penny Darras-Maxwell

Title Page Illustration:
Drawing of hand and fingerprints by Dana Lamb, student at California State University, Fullerton.

Consulting Editors: George F. Horn
 Sarita R. Rainey

Grandeurs et Lumiers, Michel Seuphor. Black ink drawing, 25¾ x 20. One of 16 panels. When assembled, they make a drawing 55 x 167 inches. Collection, The Los Angeles County Museum of Art, Gift of the Esther and Robert Robles Collection.

CONTENTS

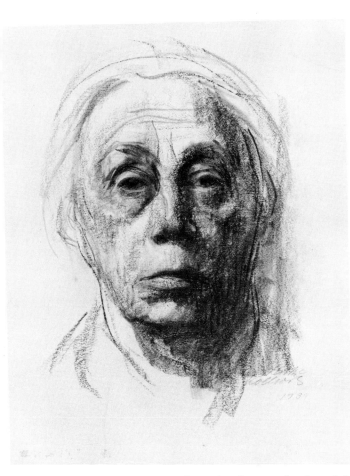

Self Portrait, Kathe Kollwitz, 1934. Charcoal and crayon drawing. Collection, The Los Angeles County Museum of Art.

58686

5

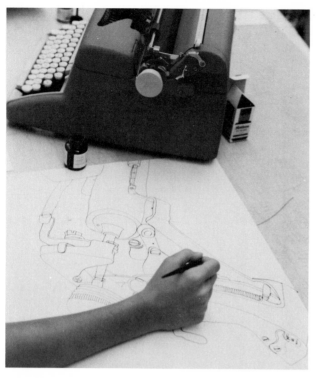

TO THE STUDENT...

Drawing is the basic language of art. Sculptors, printmakers, painters, architects and clothing designers use drawing to communicate their basic ideas. Other artists and designers use pencils or pens to doodle, write visual notes, express thoughts, and otherwise communicate with their fellow workers. Drawing is basic to visual communication. It is also a function of the artist that never stops, no matter what degree of excellence artists achieve. It is their main method of visual expression.

Without an ability to draw well, artists (students and professionals alike) are limited creatively. Drawing is to the artist what speaking is to a radio announcer. Both would be lost without their basic means of communication.

Drawing must be done constantly. As you sharpen your ability to see and record, your confidence to express yourself visually is also increased. If you stop drawing for any length of time, that ability lessens, just as an arm in a plaster cast becomes weaker due to lack of exercise. This book will help you learn to see and record (basic drawing activities), but you must try to make these activities a regular part of your daily life. Most professional artists and designers do some drawing every day. A look into their sketchbooks would help you see how they continually work to improve their capacity to see, record, and express themselves.

A look back into history will show you that the greatest artists spent much of their time drawing. You would think that they no longer needed to practice their basic skills, but they never stopped! The more you work at it, the easier it will be to express yourself and record what you see.

This book purposely contains many more ideas and suggestions than can be completed in a single year. Its goal is to provide the ideas and techniques that you need to make your expression more complete.

The book is divided into two parts. The first is designed to help you understand the various drawing media, tools, and techniques. The second suggests ideas, ways, and subject matter that help you gain experience with the materials. You may wish to use one material, pencil, for example, and go through figure drawing, landscape, still life and several other subjects with it. The opposite approach would be to take one subject matter area, still life, for example, and use a wide selection of materials to work with it. Or you may wish to combine several processes and subjects.

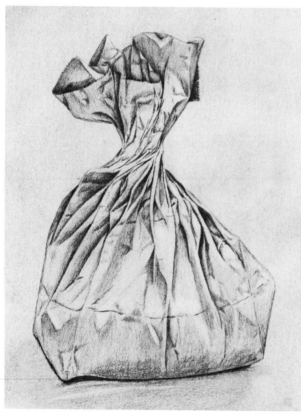

Drawing experiences, such as this student's study of a typewriter, can help you become more aware of your environment.

A college student (from California State University, Fullerton) records shadows, crinkles, folds, bulges and value changes in a pencil drawing of a brown paper bag.

6

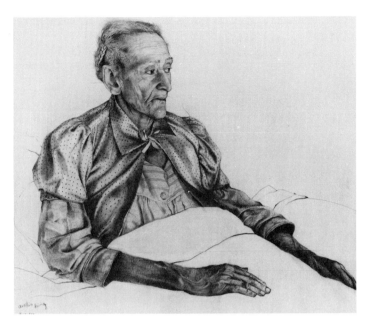

Beckie King, Andrew Wyeth, 1946. Pencil, 28½ x 34. Dallas Museum of Fine Arts, Gift of Mr. Everett L. DeGolyer.

A page of sketches by Charles White reveals a thorough knowledge of the human face. His rapidly moving pen is used to outline shade, crosshatch, and doodle. Each stroke, firm or light, is the result of years of looking and recording, as the artist's hand becomes the extension of his eye. Courtesy of the artist.

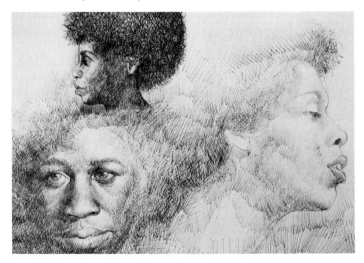

The various combinations of materials and ideas can create hundreds of projects for you to work on. Select several and establish a developmental program — one that will give you meaningful experiences and will challenge you to become more proficient in your abilities to draw.

The important thing is that you learn to see . . . record what you see . . . and draw!

Before Beginning

This book stimulates, prods and excites, but does not supply sure-fire methods of learning to draw. It will not tell you how to draw beautifully. It will show you many examples to help you become aware of the environment.

There are no course outlines in this book. Drawing should be comprised of a series of experiments, each supplementing and adding to the previous ones. Each drawing experience is different. There is no such thing as THE SUPER DRAWING CURRICULUM that can answer all those needs. The very fact that one works daily with all these changes, individuals, conditions, and differences is at once the challenge and the joy of art.

Sources for new and exciting drawing problems are banging at us every day from television, magazines and newspapers. Use them! Many of the ideas visualized in this book had their origin outside the art room. What is presented here is only a smattering of the projects and ideas available.

This book speaks mostly of drawing as action — the act of drawing, the importance of drawing. Finished drawings are not eliminated or forgotten, but the act of drawing and searching is more important at this stage of development. The drawing on the title page is a searching out of shapes, textures and form. The Charles White sketch on the previous page illustrates a complete mastery of medium and subject, although done in a sketchy and rapid technique. The Andrew Wyeth drawing on this page is a finished likeness, beautifully rendered. The student on the previous page is searching out the forms of a typewriter — she will never look at a typewriter the same way again. All these drawings are important, yet all are different in their concept and technique. Our primary goal at this level of development, the act of searching and drawing, is more important than the finished artwork.

This book presents ideas — ideas and work that have been successful. Make them relevant to your work this year (next year will be different). Take some of these thoughts and put them into action — drawing can be stimulating and exciting, dynamic with constant changes. Go off in your own direction!

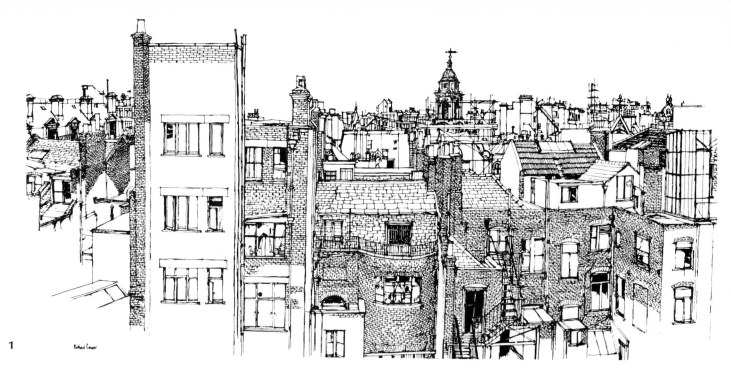

1

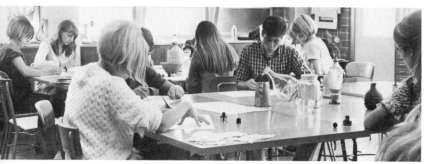

2

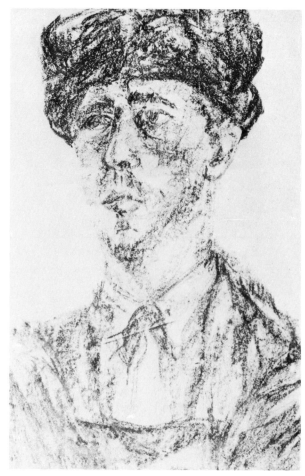

3

1 London Roofs, *Richard Downer. Fountain pen and black ink. Un-usual skill in seeing and recording are evident in this drawing. Notice the "open spaces" left in some buildings to keep the drawing from becoming monotonous. From Drawing Buildings, courtesy, Studio Vista Limited, London.*

2 *Students are recording their observations of jars, bottles and con-tainers with pen and ink on bond paper. Several such group contour studies can be made in a single period, changing tables to observe new subjects.*

3 *A large black crayon portrait on brown paper, 30 x 22 in size, shows a student's observations of his teacher in costume. Granada Hills High School, California.*

4 The Accordian Player, *Rico Lebrun. Pen and Ink, 25 x 18. The searching pen line of the artist records what he sees and feels in a sensitive sketch. Collection, The Los Angeles County Museum of Art, gift of Miss Bella Mabury.*

INTRODUCING
DRAWING

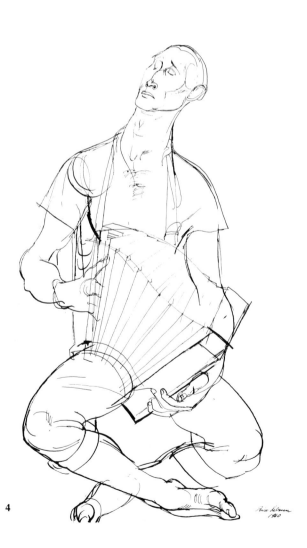

You are about to begin one of the most exciting and important experiences of your life. Your art work will be greatly influenced by your drawing experiences over the next few months. If you work carefully and are concerned about what you see and do, not only your art will be influenced, but your entire life can be changed. This is possible because learning to draw correctly is based on learning to see more completely. If you learn to see more completely, your life should be richer and more meaningful.

To define drawing in a few works is impossible. This entire book only partially defines and describes drawing, and it will be concerned principally with the verb and not the noun. It will emphasize the act and not the product — it will stress *drawing* and not *the drawing*.

Drawing implies a searching more than a finishing. To be sure, there are finished drawings, but the majority of drawings are appealing in their personality and spontaneity. They seem like fragmented statements and this feeling allows the viewer a close contact with the artist, a feeling that the work is still in progress — a feeling of immediate excitement. It provides a look into the artist's mind and his mental organization and working habits. Craftsmanship is encouraged through finished work, and some of this should be done; but constant discoveries should also be recorded, and that involves much searching and drawing.

If you look carefully at a seedpod and record its structure, textures, values and shapes, you might be seeing that seedpod in all its complexity for the first time. Look at your foot, your eye, a model's form, a still life's proportions, a tree's leaning, a flower's delicacy, an elephant's bulk. Recording your findings and feelings is drawing.

There are other sources for subject matter. The artist can recall things and make sketches of them, or he can visualize an idea or concept. Designing new products or buildings involves such visualization. Creating abstract designs and patterns is a visualization of concepts and ideas that the artist brings to reality from a fertile imagination. This visualization on paper of a nonexistent or imagined form is drawing.

Charts, graphs, logos, cartoons, letters, words and symbols are also forms of graphic expression. Small children develop a system of symbols in their drawing, and their intrigue with such visual representation stays with them all their lives. They

9

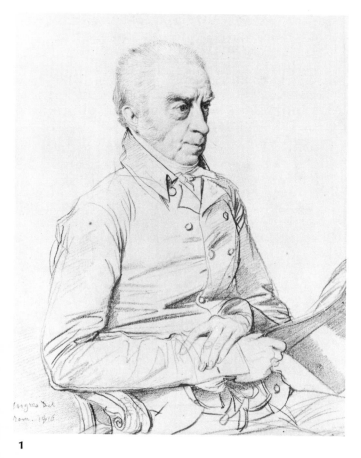

1

are not describing or visualizing but are symbolizing. Placing this on paper is drawing, and the graphic product is a drawing.

These three areas overlap and intertwine, but can be unraveled for study. All of them will be treated in this book, but the first — recording what is seen — will receive the most emphasis because you and other students are a searching, inquisitive people. Recording your visual discoveries with graphic media is exciting, and it is a drawing.

Becoming aware of your environment in both its intimate and all-inclusive aspects is a vital experience. This awareness is strengthened only by looking and seeing. One artist has said, "I am constantly wearing out my eyes," and his drawings show a fantastic concern with observed facts. The way you see and feel about your environment (people and things) will help determine your ability to draw. Seeing and drawing are inseparable. Drawing is one way of seeing.

A Brief Look Back

Drawing begins with history, with the French and Spanish caves giving us our earliest records. Drawing moved from walls to rocks, to pottery jars, to Egyptian walls and papyrus. Greeks and Romans ignored earlier ritualistic restrictions and produced quite naturalistic art which later had a strong influence on Renaissance drawing.

During the Middle Ages, drawing was the servant of the church, and mostly in the miniature form of manuscript illumination. Large cartoons (working drawings) were made for stained glass windows, but these were later destroyed.

Drawing, as we know it today, had its start in the fourteenth century Italian Renaissance. Apprentice artists drew from earlier master paintings, and drawing became the foundation of the arts. Drawings were made prior to producing large frescoes, easel paintings or sculptures. Silverpoint, pen and bistre, charcoal and chalk were the popular drawing tools. A constant growth in visual awareness finally produced the marvelous drawings of the High Renaissance and the work of Leonardo da Vinci, Michelangelo, Raphael, Titian, Dürer and Holbein.

Sixteenth century Baroque artists produced huge and masterful drawings that were done freely and with great strength. The human figure was still the major subject, but its handling became brilliant and expressive. Wash drawings that could produce dramatic dark and light contrasts were the prime medium of Guercino, Tiepelo and Guardi. Reed pens produced most of the hundreds of drawings generated by Rembrandt. Rubens' exuberant work was done mostly with red or brown chalk with white or black accents. His freedom and strength influenced many artists that followed.

French and English Rococo artists produced portraits and courtly scenes, although Hogarth's biting satire in pen and ink revealed the foibles of English social life. In Spain, Goya left

1 Portrait of Thomas Church, *Jean-Auguste-Dominique Ingres, 1816. Pencil, 7½ x 6¼. The Neo-classic draftsman took great care with the facial features, but his pencil flew quickly over the rest of the figure. Courtesy, The Los Angeles County Museum of Art, The Loula D. Lasker Fund.*

2 *Ninety-three-Year-Old Man. Albrecht Dürer, brush, India ink, white color on grayish-violet paper, 16⅜ x 11⅛. Expression and technique are in careful balance. Courtesy of the Albertina Museum, Vienna, Austria.*

3 Rest on the Flight into Egypt, *Rembrandt, 1655. Reed pen and bistre, 6⅜ x 8⅞. Rapid pen work and a fertile mind are evident in Rembrandt's sketches. Studies for possible paintings, they show compositional thinking and planned areas for value contrasts. Courtesy, The Los Angeles County Museum of Art, the Norton Simon Foundation.*

4 Study for the Libyan Sibyl, *Michelangelo, 1511. Red chalk on paper, 11¼ x 8⅜. A drawing from life to be used as part of a figure for the great Sistine fresco. Michelangelo drew constantly in preparation for paintings or sculptures. Courtesy, The Metropolitan Museum of Art, New York.*

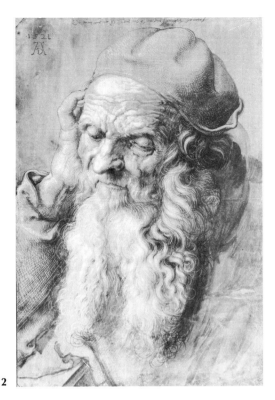

2

many chalk and wash drawings that likewise spoke out against the existing social structure.

The classical revival of the nineteenth century had Ingres as its chief draftsman, and his pencil was meticulous. The Romantic artists, such as Delacroix, used pen and ink with explosive energy while the realists, under Corot, preferred chalk and charcoal for their rural scenes. Daumier's expressive caricatures were drawn with agitated charcoal or ink line and shaded with washes.

The Impressionists' passion for light produced the airy charcoal or brush and ink drawings of Manet and Degas, though the pencil became a favorite tool of both. The Post-Impressionists, Cézanne, van Gogh and Seurat, began the era of drawing, dominated by the individual approach and style, which is vitally alive today.

Twentieth century drawing is characterized by search and change, each artist working in his own style and each constantly growing and changing. And any medium goes. It is this concept that leads to the fresh and dynamic approaches that drawing is taking today. The long string of history provides the background for all drawing classes in our schools. We are not drawing in a vacuum, but are the end product (though constantly changing and growing) of a continuum that began with man's initial scratching on a rock wall.

3 4

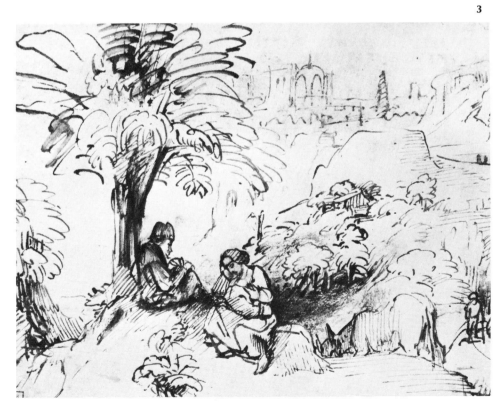

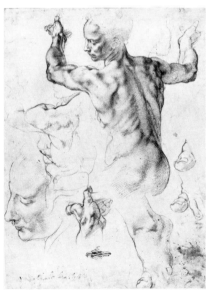

11

Developing an Individual Style

"I like Rembrandt's line quality."
"That looks like a Rubens' drawing!"
"Andrew Wyeth can really draw!"
"That looks like a da Vinci face, doesn't it?"
"Isn't that a Seurat charcoal study?"

How can you tell who made the drawings without looking at the name of the artist? Simple — you recognize a style of drawing. It is as much the artist as his/her handwriting, his/her way of talking, or his/her poetry. You know it is a Michelangelo drawing by his individual style — and you should know a Bill Smith pen and ink by his individual style. Of course Bill is only in the tenth grade and is just developing his style. It will not be matured for years, but he is beginning to have a style of his own.

A class of twenty young artists should be turning out twenty versions of the model, not twenty copies of the same version. And if the teacher works along with the class, there will be twenty-one versions, all different. Many parents feel that the student's work should appear similar to the instructor's work in style. That would make the teaching of drawing easy and simply a matter of copying. You should learn to look for yourself and make your own individual, visual statement about the subjects you draw. In that way, your personal style begins to develop. That is the real joy of drawing.

1

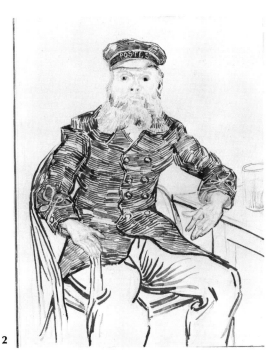

2

1 The Banjo Player, *Francis de Erdely. Balsa stick and ink on brown paper, 29½ x 24. The artist's style shows a strength of form, particularly in hands, feet and face. His drawing style developed from careful observation. Courtesy, The Snow Gallery, San Marino, California.*

2 The Postman Roulin, *Vincent van Gogh, 1888. Reed pen and ink and black crayon, 23¼ x 17½. Notice the short jabbing pen strokes that are so similar to the artist's brush strokes in his paintings. Facial features and attire both contain the same strokes — van Gogh's distinctive style. Courtesy, The Los Angeles County Museum of Art, Mr. and Mrs. George Gard de Sylva Collection.*

3 Sausalito Dwellers, *Robert E. Wood. Pentel sketchbook drawings, 17 x 11. Wood's emphasis on action characterized his personal style, showing interacting figures. Sketched from observation. Courtesy, the artist.*

3

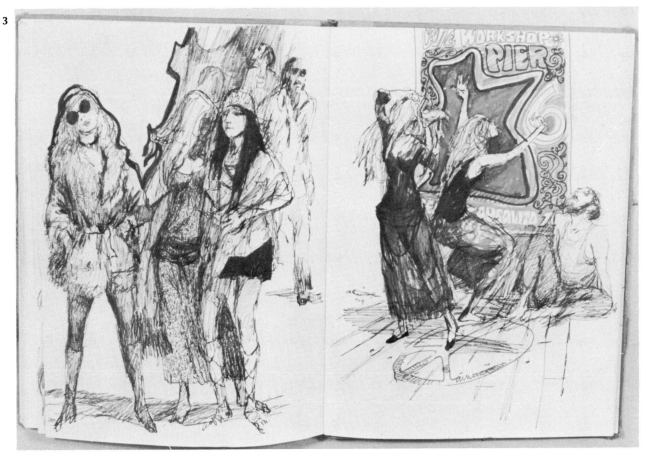

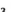

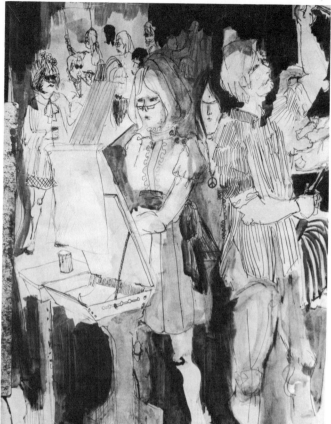

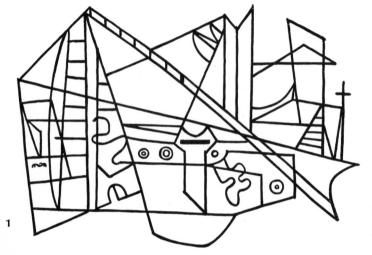

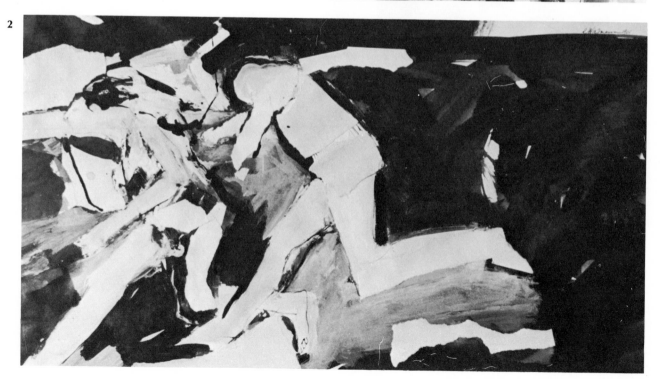

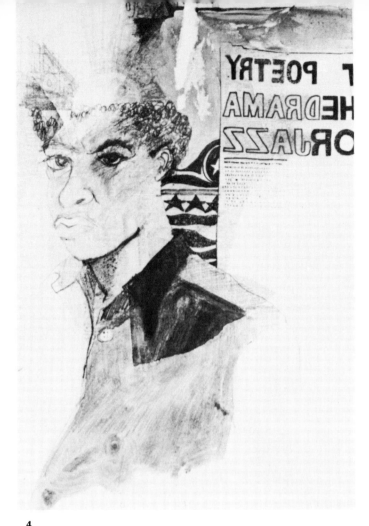

4

The search for an individual style is endless, but it has to begin in your drawing class. You can begin by trying many ways of working. Use bold strokes or delicate lines; draw with vigor or with flowing lines; make dramatic statements or realistic renderings. Feel free to experiment and try new techniques and materials. You are not in class to make masterpieces, but to experiment and learn! You should not force yourself to stick to one method of expression, but enjoy the freedom of trying many styles of drawing. Your own personal style will develop in this learning process.

You can also look to outside sources to help you develop your style. Everything you see or come into contact with will have some effect on your work — movies, art shows, comic pages, books, museums, television, your teachers, and your classmates and their work.

Look at the drawings of artists of historical importance for feelings and concerns which might be similar to those of your own. Visit local galleries to see what is happening now, or look through the art magazines in the library. Glance through art books and notice the drawing techniques being used. Expose yourself to a wide range of drawing experiences in subject matter and materials. To all of these experiences (the more the better), add your own cultural background, feelings and personal experiences. With all of these individual characteristics, how can your work look exactly like that of anyone else? It shouldn't. It will be your own personal statement about the subjects.

1 Composition #4, Stuart Davis, 1934. Brush and ink, 21⅜ x 29⅞. Davis' linear structures are carefully drawn with his brush. His style makes use of strong lines and hard edged contours. Courtesy, the Museum of Modern Art, New York, gift of Abby Aldrich Rockefeller.

2 Adam and Eve Fleeing, Richard Wiegmann. Ink and collage. The artist's work is mostly oriented toward the human figure, and he explores it in all media. But his style is easily recognized, even in this sketch which stresses rapid movement. Courtesy, the artist.

3 Constantly searching for his style, this young artist explores his immediate environment — the art room. Ink and wash, 22 x 17. Gardena High School, Gardena, California.

4 The search for a style takes the young artist in all directions. This mature statement is based on observation and a strong desire to communicate. Collage and ink and crayon drawing. Fremont High School, Los Angeles.

Drawing and the Graphic Elements

An awareness of the principles of design and the elements of drawing should not be memorized facts. If they are sensitively felt, they can become part of your own style. Examples in this book will constantly draw attention to the design principles. These examples and other drawings that you see can strengthen your knowledge of the design concepts until, finally, they are *seen* and *felt*.

The elements of drawing are tools to use, and should be talked about, understood and used. Line, shape, value, texture, color and space are the basic elements of art. Color is found mostly in the realm of painting, but will be discussed later as it relates to contemporary drawing. Space and perspective are handled in Chapter 8. That leaves line, shape, value and texture.

Line

Line is the most important of all graphic elements. Though not present in nature, it is the most convenient device for dividing, containing, directing, describing or expressing. It can be thin, thick, varied, straight, curved, agitated, broken, solid, wiggly, hard, soft, fuzzy. It can be made with any of the drawing media and can be sketchy, emphatic, searching, careful, controlled or free. It makes letters and numbers as well as leaves, eyes and hair. It can show depth, simulate texture, indicate stress and produce excitement. It is the most versatile and necessary of all the graphic elements.

Shape and Form

Shapes are often contained by lines, but can be solid or textured. They take up an area of the drawing and can be described as geometric (square, round, triangular) or as organic (pear shaped, free flowing, leaf-like and a multitude of descriptive shapes). Shapes can feel solid, wiggly, strong, weak, thin or fat. If they are overlapped or shaded they will feel three dimensional and we call them forms. Shapes and forms can occupy positive or negative space in a drawing, each being as important as the other. They can be outlined or solid, produced by a line or a flat brush, in any media.

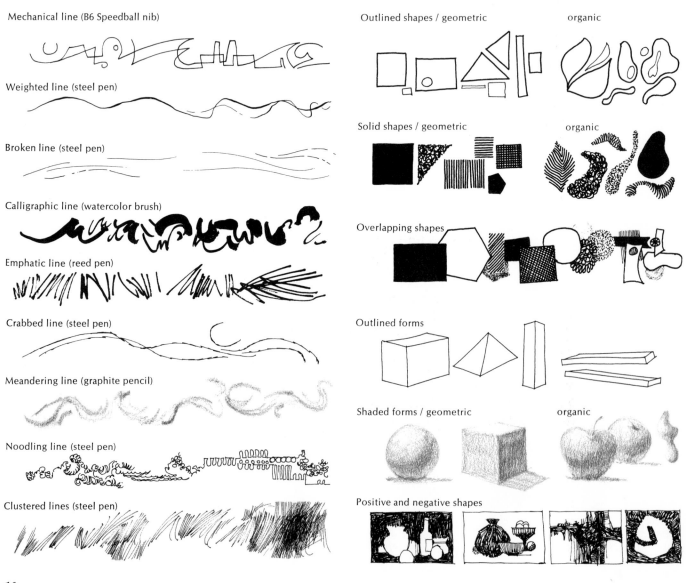

Mechanical line (B6 Speedball nib)

Weighted line (steel pen)

Broken line (steel pen)

Calligraphic line (watercolor brush)

Emphatic line (reed pen)

Crabbed line (steel pen)

Meandering line (graphite pencil)

Noodling line (steel pen)

Clustered lines (steel pen)

Outlined shapes / geometric organic

Solid shapes / geometric organic

Overlapping shapes

Outlined forms

Shaded forms / geometric organic

Positive and negative shapes

16

Value and Tone

Value or tone refers to the lightness or darkness of the object. Light values feel delicate while dark values show strength. A strong contrast in values produces drama. White is the lightest value and black is the darkest, with all the intermediate values forming grays. Most values are drawn by shading or by using gray washes, but pattern can also produce a feeling of gray. As light moves over a three-dimensional object, it changes in value from light to dark. Illustrating this change in value is called chiaroscuro (a system of light, shadow, reflected light and cast shadow). Tones can be flat or three dimensional, but they always control the light factor in a drawing.

Texture

Textures (the tactile quality of a drawing) can be actual or simulated, but in the graphic media most of them are simulated. Drawings using some collage will have actual texture, a gessoed panel will provide a textured ground, and a rubbing will be based on relief. Some papers (charcoal, textured drawing paper, matboard, etc.) will provide an overall textural feeling. But most drawn textures will be an illusion produced by the artist on a flat surface, many of them formed by patterns created by the artist. Careful observation and practice provides the method for creating this illusion. An individual object might be textured in the drawing, or the entire drawing may appear as a textured surface. It is an illusion at times — or is it?

Light values (high keyed)

pencil

pen and ink

wash charcoal

Actual textures (all recorded with a flat pencil)

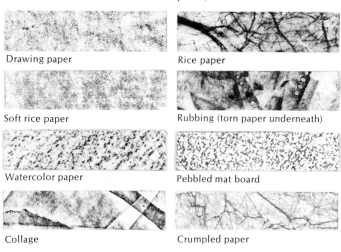

Dark values (low keyed)

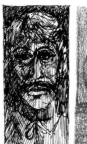

wash

pen and ink pencil charcoal

Value contrasts

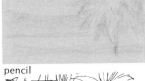

pencil

charcoal

brush and ink pen and ink

Simulated textures

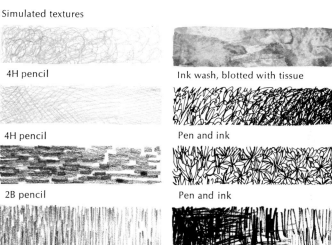

17

Drawing Media — a Quick Look

The variety of media available today is astounding but can be grouped easily for convenience, as seen in the three chapters that follow. Each medium has its own character, something about it appeals to the artist who uses it extensively. It fits his specific requirements, but this is discovered only after much trial and experimentation.

The media differ and so do the surfaces. The papers are soft or hard, smooth or with tooth, absorbent, wet, dry, wrinkled or textured, and a medium will react differently to each one.

CHARCOAL

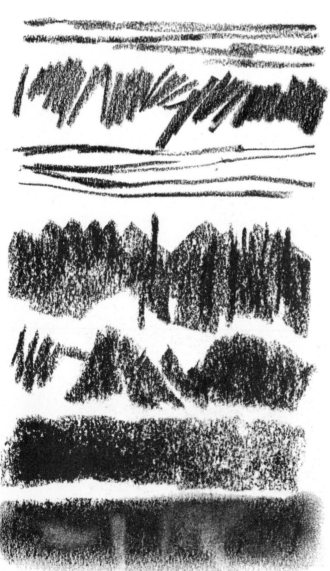

PENCIL

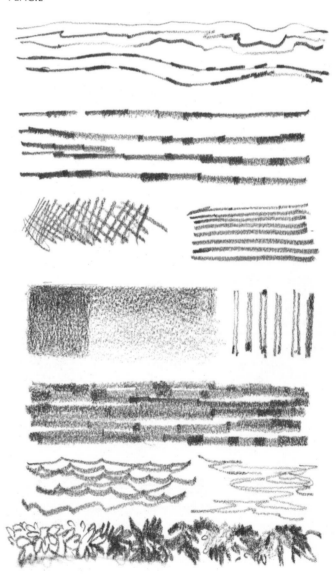

The *shape* of the medium is also important — the length and width of the pencil, its thickness, roundness or whether it breaks easily. The loaded brush produces different marks than a partially dry one.

Keep experimenting with media and paper. Different graphic marks are produced by different tools or by different lengths of the same kind of tool. Hold the pencil in a number of ways; see what it does in each way. Try the same things with long charcoal sticks and stubs, broken crayons or whole crayons. Experiment and see what works best. Here are some basic media and their marks.

PEN AND INK

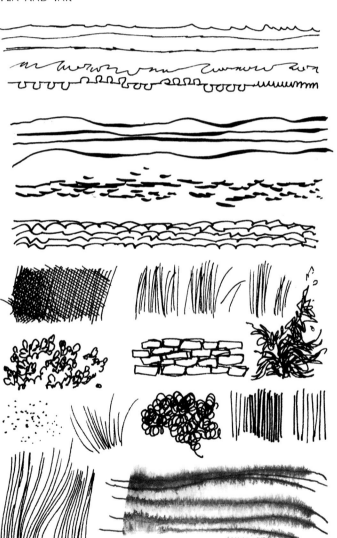

BRUSH AND WASH

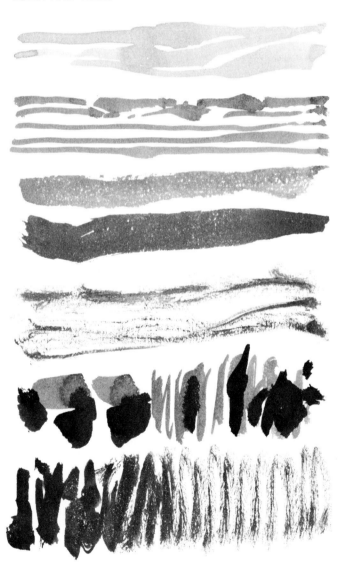

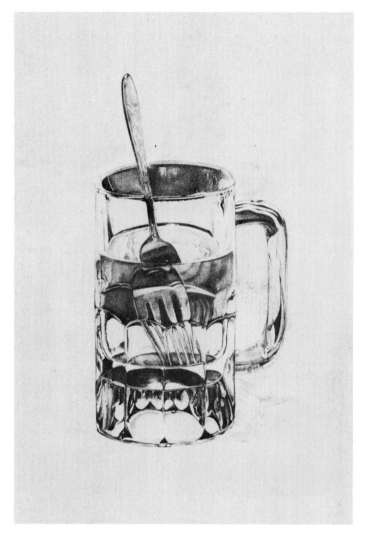

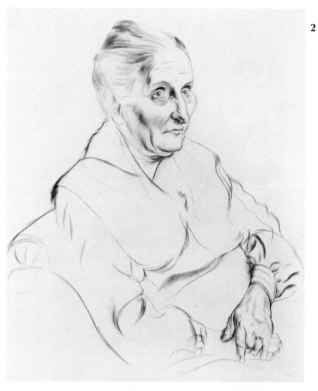

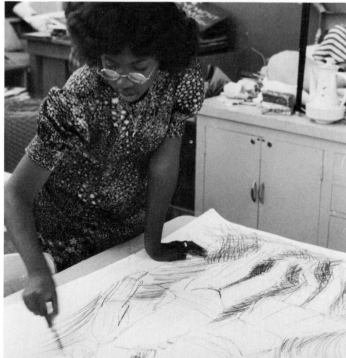

1 *Working with pencil, a student captures the peculiarities of the visual distortions that water and glass can create. California State University, Fullerton.*

2 *Portrait of Anna Peter, George Grosz, 1926. Pencil, 26⅝ x 21. Notice the selective shading and the emphasis on face and hands. Grosz made this pencil drawing of his mother-in-law in a traditional and representational style. Collection, The Museum of Modern Art, New York, gift of Paul J. Sachs.*

3 *Dry media are quick and easy to apply on small drawings, like those of Ingres, or on large sheets of paper.*

4 *Face Study, William Pajaud, pencil. The artist uses the versatile pencil for two distinct techniques — simplified line and detail shading. Courtesy of the artist.*

2

DRY MEDIA

Selection of media used in any drawing is really the artist's personal choice, often determined after many struggles with a wide variety of materials. And this struggle and confrontation should take place in the art room, also. If the art room is an experimental workshop, then you should be experiencing a variety of media. At some point, it would be beneficial if you come in contact with the complete range of drawing materials. You could try them separately, mix them, attempt various combinations, experiment with techniques, and generally see what each one does. These searchings can take place with a variety of subject areas and on a wide range of papers. The combinations are almost endless, which should keep drawing from becoming boring.

Basically, drawing media can be divided into two convenient areas: dry media and wet media. Each one has its own qualities that make it a favorite of various atists. The rich velvety blackness of India ink is in sharp contrast with the silver gray of a 6H pencil. The grainy texture of a dry brush sketch is quite unlike the drippy wetness of a slurpy wash drawing.

The dry media are basically graphic and the wet media are generally more painterly, consisting of a range from wash drawings with water or oil, to various applications of ink, ball-point pens and fiber-tipped drawing tools. The dry media range from charcoal and chalk to crayon, pencil and even scratchboard. The attributes that give these materials their characteristic qualities of roughness, smoothness or wetness, can be turned around and used to advantage. Pen and ink is usually a detailing medium but can be quite free and sketchy. Charcoal, which is generally soft and loose, can be worked with fine detail as well. The fascinating point is the materials can be presented and demonstrated, but what you do with them is your own decision and is part of your unique style. The individual and creative application of common materials makes each drawing a unique communication.

4

1

2

Pencil Drawing

By the time you reach high school, you have been using pencils, in one form or another, for many purposes, for nearly ten years, and are probably inclined to look down on them as "kindergarten materials." Indeed, it is the most available and economical of all drawing tools. But the lowly pencil (from the Latin *penicillum,* meaning "little tail") has a rich history, being a direct descendant of the metal stylus (silverpoint) that the Romans used. This stylus makes a delicate light gray line and must be drawn on specially prepared abrasive paper. Several professional artists still use this exacting medium today, but it is too demanding for ordinary school use.

About 1400 A.D. there appeared in Italy a sort of pencil, made with a combination of lead and tin. It was used for sketching layouts and ideas on sheets of economically produced paper. Since later Baroque artists were interested in large works with much value contrast, this pale line-producing tool was little used. When graphite replaced lead, more pencils were used, and finally in 1795, the French inventor Conté developed a pencil material by mixing graphite and clay, and baking the result. The Germans and English found economical methods of production, and this is basically the tool that we still use today. Most artists of the past have used pencils to probe and search for forms to use in painting. Today, with our seeming need for speed in all we do, the pencil has come into its own. It can be handled in many ways, but its unique ability to be delicate, strong, vibrant and sensitive have made it a vital drawing tool.

The pencil is the most immediate of contemporary drawing materials. With it the artists can record a variety of lines, tones, feelings, moods and ideas — immediately. There is nothing to dry; the only tools needed are pencil and paper. Drawing is spontaneity: the delicate face of a child ballerina, the tension of a street demonstration, the tenderness of a hand-in-hand couple, the crash of two football players, the fright of a young soldier in war. Drawing is a way of recording personal history, with the pencil as the tool.

Pencils come in an almost infinite variety: graphite, charcoal, carbon, conté, lithographic and a host of colored pencils. The most useful, graphite, comes in a variety of shapes (round, flat, hexagonal) and hardnesses (from 6B, the softest, to 9H the hardest. There are seventeen in all). Though called a lead pencil, its basic material is really graphite, a greasy form of carbon, that is still mixed with clay; the more clay there is, the harder the pencil and the lighter the line. Originally these pieces of material were inserted in a metal holder while working, but now are encased in wood for convenience and protection.

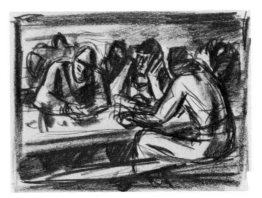

4

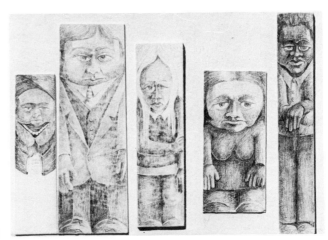

5

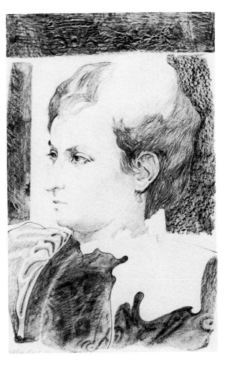

1 *Each flower was held separately in the left hand and drawn with the right. The entire surface was then reworked to provide a feeling of unity. Pencil, 22 x 17. Birmingham High School, Van Nuys, California.*

2 *Careful observation and a directional pencil stroke make a strong visual presentation. A fine range of values culminates in the area of emphasis, the statues. Pencil on paper 21 x 16. Gardena High School, Gardena, California.*

3 *The American Hay Company, 1962, Robert Indiana. Pencil drawing, 25⅛ x 19. Indiana obtained a striking graphic image, in this stencil rubbing, by allowing the individual pencil strokes to be important. Collection, The Los Angeles County Museum of Art, gift of Mr. and Mrs. Cecil V. Comara.*

4 *Untitled sketch by Francis de Erdely. Pencil, 5 x 7. Pencil works well on such thumbnail idea sketches as this small compositional and value study for a possible large drawing. Courtesy, The Snow Gallery, San Marino, California.*

5 *Contained Figures, Roland Sylwester. Pencil on gessoed cardboard shapes, 8 x 12 overall. A gessoed surface provides an interesting ground for pencil drawing, but the intriguing part of this work is the concept of trying to contain figures in rectangular shapes. Courtesy, the artist.*

6 *Willie Risinger, Robert Wendell. Pencil and rubbing, 11½ x 7½. A carefully drawn portrait study is enhanced with pencil rubbings of various textures, a feeling which a wet medium could not provide. Courtesy, Orlando Gallery, Encino, California.*

6

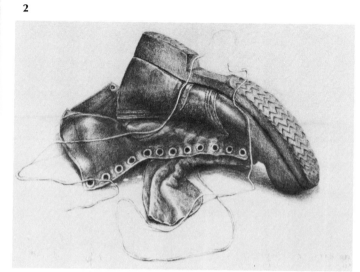

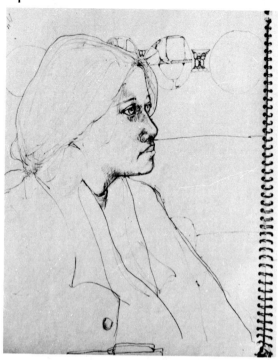

Almost every type of paper can be used with pencils, but the smoother papers that border on being slick should be avoided. A slight tooth (grain) is preferred. Bond paper, drawing papers of various weights, charcoal paper, oatmeal paper, and newsprint are a start. They should be tried with pencil at one time or another. The same contour drawing of a still-life can be drawn on successive days with the same pencil; but if different papers are used, the result will be different. Also, you will *feel* different because the drag of the pencil on the surface will offer a different sensation.

And size need not be a limiting factor. Some pencil techniques call for small sized sheets while others require large and still larger sizes. Pencil drawing can take place on a sheet of typing paper on a table or desk; or it can be handled on a 36 by 60 inch sheet of butcher paper placed on the floor. Or it can be done on a 4 by 8 foot sheet of plywood which is leaning against a wall.

The pencil can be held in the traditional drawing posture, between the thumb and first two fingers; or it can be held across the palm of the hand, especially when larger work is done. It can be held close to the point or manipulated from near the other end. At any rate, it should be changed in its position in the hand from time to time, depending on the nature of the technique being explored.

The more pressure that is exerted on the paper, the darker the line will be, up to a maximum darkness for each hardness of lead. If darker lines or masses are to be drawn, then softer pencils must be used. Drawing pencils also vary in thickness of

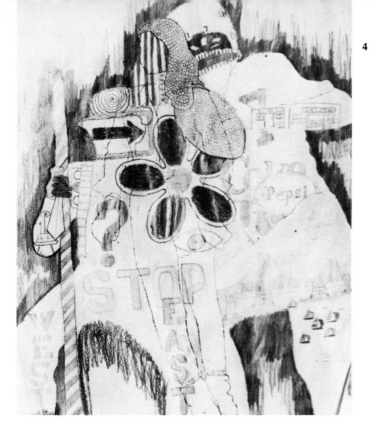

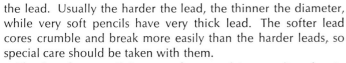

the lead. Usually the harder the lead, the thinner the diameter, while very soft pencils have very thick lead. The softer lead cores crumble and break more easily than the harder leads, so special care should be taken with them.

The fact that pencil lines can be erased is appealing, but in reality is also one of its few drawbacks. The pencil is useful for making quick sketches, for producing finished drawings, or for setting the feeling for a composition that will be finished in another medium. It can produce line and tone with equal ease and is the major drawing tool of most artists.

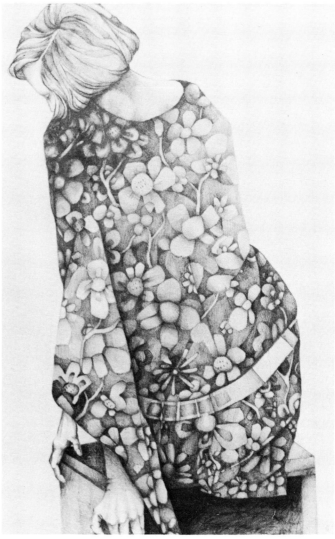

5

1 *Sensitively selective in his pencil shading, this student has caught the feeling of his model by observing with great care. The sketchbook drawing is from the Los Angeles City Schools Special Scholarship Class.*

2 *Careful observation is necessary to see the value changes that can produce an accurate rendering, such as this boot. Pencils are capable of a wide range of values from light gray to solid black. California State University, Fullerton.*

3 *Douglas Robinson combines colored pencils with regular drawing pencils to produce extremely sensitive and subtle images. Composition with Horseshoe Crab, 37 x 38, is on a single sheet of paper but is drawn to look like a series of matted drawings. Courtesy of the artist and Challis Galleries, Laguna Beach.*

4 *Experimental pencil drawing made by transferring several outlined and overlapping figures on a 12 x 10 sheet of drawing paper, then filling in the positive shapes with extraneous details of various textures and values. Lutheran High School, Los Angeles.*

5 *Girl, Tom Sylwester. Pencil, 24 x 16. The fabric pattern dominates this drawing, but the hands and head give it purpose. Elimination of background sets the detailed figure apart and makes it important. Courtesy, the artist.*

Charcoal Drawing

Charcoal is probably the oldest of drawing materials, since early man undoubtedly drew on the walls of his cave with chunks of burnt wood. There are written accounts of Greeks using it as a drawing material, and evidences abound that the Romans used it also; but until fixatives were invented about 1500, such drawings couldn't be kept. The material itself comes in several forms: stick charcoal (formed by burning all organic materials from twigs or sticks and leaving only dry carbon); compressed charcoal (made by grinding charcoal into powder and compressing it into sticks, varying in darkness according to the amount of binder added); and charcoal pencils (which are really compressed charcoal, sheathed in wood, also varying in softness). The compressed sticks range from softest and blackest (00) through 0 to 5, the lightest and hardest. The pencils run from softest (6B) through 4B and 2B to HB (hardest and lightest). The pencil is naturally the cleanest way of using charcoal, but only the point can be used effectively. With other types of charcoal, as the sticks, the sides as well may be used, allowing another method of working and therefore greater flexibility. Charcoal is the blackest and driest of the dry drawing media.

It is the flexibility of the material that is appealing. If you are timid about drawing large, use charcoal and large sheets of paper (both in liberal doses). Because charcoal is easily erased with kneaded rubber erasers and smoothed with a cloth or chamois, you can work rather freely with it. This erasability is also a drawback, since the material smudges easily and becomes rather dirty. But these factors can work to one's advantage by encouraging experimentation and freedom of expression.

With a little purposeful smudging, beautiful soft edges and tones can be achieved. Hard lines can be drawn with a sharpened point. Its great versatility makes charcoal an exciting drawing and sketching medium.

When the drawing or sketch is finished, it must be *fixed* to be preserved, or else the drawing will smudge and smear. Several companies produce spray fixatives; or charcoal fixatives (shellac or transparent lacquers or plastics) can be sprayed with a hand or mouth atomizer. Some artists spray their work at several stages, while others wait until finished before fixing the drawing.

Papers again are a matter of personal preference. After searching and trying several, you should find the type that best fits your style, technique and subject matter. Newsprint is very good for quick sketches; drawing papers, bond paper and charcoal paper are all excellent. The latter will take the most punishment by way of erasing and working over areas, but each paper has a quality that makes it attractive. Try them all and feel how they work.

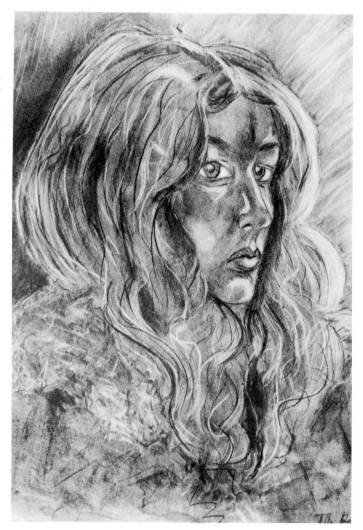

1

26

Papers that are smoother than bond paper will not have enough tooth to grab the powder from the stick, and papers that are too rough might grab too much. Experiment and see. There is no "official paper" for charcoal.

Various effects can be achieved by rubbing the charcoal with certain things. A small square of chamois will produce a very soft tone; a finger, hand or arm will give another effect; a kneaded rubber eraser will clean out a small area; and paper stumps or tortillons (pencil shaped rolls of soft paper) can be used to rub small or medium-sized areas to produce an even gray tone.

Before beginning any problem, you should experiment a bit. Hold a variety of charcoal materials in different ways. Try broad strokes, using the side of the sticks. Use a round-shaped piece, a soft or hard pencil. Sketch lightly, press firmly, scribble, crosshatch, try tiny detailing — try them all. Then, when drawing, use the tools and techniques that work best for you. Try various effects by rubbing, smudging, erasing and reworking. There is no single "correct" way of working with charcoal.

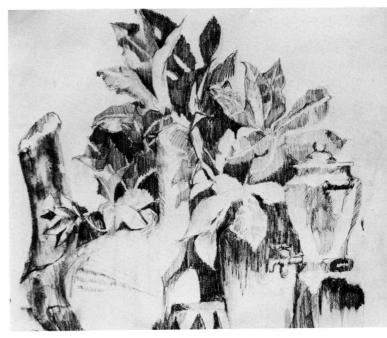

2

1 *Smudging and rubbing the applied charcoal gives a smooth texture, while lifting some areas with a kneaded rubber eraser can provide dramatic highlights. Done on gray paper, this 24 x 18 work is from Birmingham High School, Van Nuys, California.*

2 *Directional strokes of the charcoal help unify the elements of a complex still life. This 18 x 24 drawing on bond paper is from Lutheran High School, Los Angeles.*

3 *A 24 x 18 blowup of a portion of a face provides an excellent subject for shading with charcoal. Reseda High School, California.*

4 *Charcoal study of an old shoe uses excellent blend of softly rubbed areas and a discriminating use of line. The 16 x 8 drawing on brown paper is from Granada Hills High School, California.*

3

4

27

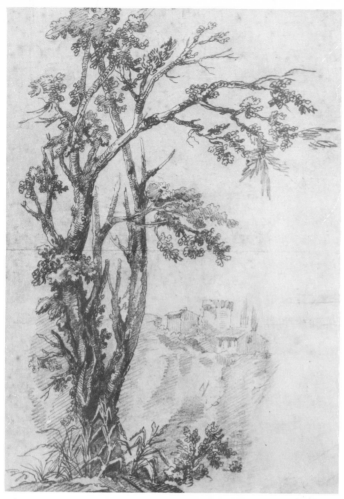

1

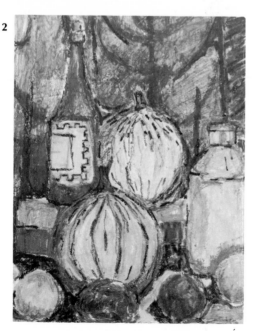

2

Chalk Drawing

Chalk, along with charcoal, is really an ancient drawing material used in cave drawings and paintings in Spain and France. Chunks of chalky earth materials were used just as they were taken from the ground. Natural carbons made black, iron oxides were the reds, umbers produced a variety of browns, ochres made earthy yellows and chalk produced white. During the Renaissance, sticks were formed of these materials and the artists produced large scale drawings in several colors. Red and black were then the most common colors with highlights added in white chalk. Often these works were drawn on tinted papers which added still another color and value to the drawings. With their passion for depicting the rounded forms of the body, this drawing technique was most popular.

It is difficult to tell where chalks end and pastels, crayons and charcoal begin; or where drawings end and paintings begin. Like charcoal, chalks vary in their degree of hardness and permanence, as well as their oil content and color intensity. The softest and driest of chalks are referred to as pastels and this medium is perhaps best treated in books on painting. Because of the use of color and the techniques involved, pastel drawings tend to be worked in a manner more like painting; while chalks, being harder and lighter, tend to be worked in a more linear fashion, like charcoal.

Chalk drawings are most effective when the variety of color is limited and the material is handled like charcoal, in a graphic way. Try studies using black and white chalk on colored construction paper to search for ways of emphasizing form. Or limit the drawing to one or two colors with black chalk mixed in for shadow, tone and dark values. Chalk drawings of this type, like charcoal work, must be sprayed with a fixative to keep them from smearing.

Chalk may be dipped in starch (which immediately makes it a wet medium) and applied to the paper, thus eliminating the need for a fixative. Chalk sticks can be dipped in water, or applied dry to a dampened paper surface, but this work must still be fixed when done. This type of application may take on the color and textural appearance of a painting.

All the papers that work well with charcoal are acceptable for chalk drawing. The harder the chalk, the more tooth the paper must have. Regular charcoal paper or pastel paper (which come in a variety of colors and grays) is best if much working and reworking is planned. Its tooth also will cause more color to be left on the paper. But newsprint, bond papers and various weights and textures of drawing papers are very usable. Construction papers (in many colors) and bogus paper (in large sizes) provide interesting color and textural surfaces on which to work.

Conté and Lithographic Crayons

Conté is a fine textured and oily material that has a more adhesive quality than chalk or charcoal. It is made expressly for drawing and comes in stick form about a quarter of an inch square and three inches long, and also in pencil form. It comes in three degrees of hardness and three degrees of intensity: No. 1 hard, No. 2 medium, and No. 3 soft. And it comes in four colors: white, black, sepia and sanguine, an earthy red color that is the most popular of the conté colors. Though the techniques of working are similar to those of charcoal, the added colors and smoother texture are often a welcome relief from the powdery charcoal.

If a less greasy material is desired, try Othello pencils. These have a wide range of colors and are less greasy than conté crayons but more sturdy than charcoal.

If a more greasy material is required, lithographic crayons (made for working on lithographic stones) and oil pastels or oil crayons may be used. Each material has certain qualities that are appealing and only working with each of them can help determine your likes and dislikes. Decisions as to the desirability of the medium can only be made through experimentation.

3

4

1 Study of a Tree in a Landscape, *Antoine Watteau (1684-1721). Red chalk on paper, 17¼ x 12¼. Darker values direct your eye to the detailed foreground tree, while the distant landscape is lighter and less complete. Notice the strokes left visible. Courtesy, the Norton Simon Museum of Art in Pasadena.*

2 *Still life drawn with colored chalks dipped in starch as a binder. Surface becomes almost painterly in this 24 x 18 work from Lutheran High School, Los Angeles.*

3 *This self portrait in front of still life material is done in conté crayon on a 24 x 18 sheet of drawing paper. John Marshall High School, Los Angeles.*

4 *Holy Family, Gerald F. Brommer. Lithographic crayon on matboard, 18 x 8. The crayon is a good sketching tool, the pebbled matboard provides the texture for this sketchy Christmas concert program cover.*

1

2

1 *This giant (33 x 22) drawing of part of the instructor's face is done with the side of a purple crayon on wrinkled brown kraft paper. When blown up to such monumental size, the work demands careful observation as to relative facial proportions. Granada Hills High School, California.*

2 Football Players, *Francis de Erdely (1904-1959). Crayon and etching, 21 x 27. Several colors of crayon were applied heavily over each other in controlled areas, with lines and shapes then scratched or etched into the result. Courtesy, The Snow Gallery, San Marino, California.*

3 *The sgraffito technique (crayon etching) is one of scratching through a layer of black tempera painted over heavily applied wax crayon. Effect is similar to scratchboard except for the color. This 9 x 12 example of insects and leaves is from Paul Revere Junior High School, Los Angeles.*

4 *This black crayon drawing (24 x 18) employs cubist techniques to fracture the surface. Both the ends and sides of crayons were used. Birmingham High School, Van Nuys, California.*

3

4

Using Wax Crayons

Because of their familiarity and the recollections of early school years, the wax crayon is often neglected as an art medium. But this versatile material which can be handled in so many ways and so effectively in combinations with other media, is a valuable addition to the drawing experience.

Using paraffin as a binder, wax crayons come in a wide range of colors and sizes, from pencil size to sticks a half inch in diameter. They come with paper wrappers (which should be removed) and without. They cannot be erased and like pastels, can almost be thought of as painting tools rather than drawing materials. It is really in the application of the medium that it may be classed as a drawing tool.

Wax crayons can be used in bold and vivid techniques or in subtle and delicate ways. Color can be applied with the tip of the crayon or with vigorous broad strokes using the side of the stick. Subject matter can be sketched in line or drawn, colored and rubbed into a finished drawing. One color can be worked into another, and colors can be blended and polished by rubbing with a paper towel, soft cloth or small paper squares.

Color can be applied in heavy doses and then scratched through to the paper in a sgraffito effect.

The paper can receive a heavy coating of color in various patterns and then be covered with a solid application of poster paint or India ink (the ink adhering better if a light dusting of talcum powder is made on the crayon surface). Lines can then be scratched through the black surface to reveal the gleaming wax colors underneath. This crayon etching method is the same as the scratchboard technique discussed next.

Try drawing on the paper with heavy bright-colored lines, and then covering the drawing with a *wash* of black or dark value watercolor. This is really a wax-resist technique and is discussed more in Chapter 4, on mixed media.

Wax crayons can be used in making rubbings when searching for textures. They can be ironed, melted, rubbed, scratched, covered and mixed with other media in an infinite variety of ways. Make color and texture swatches using wax crayon in different ways or combined with different materials on each swatch. You may come up with twenty or more techniques, and perhaps some that haven't been explored before. Such is the versatility of the lowly wax crayon.

1

Scratchboard Techniques

Scratchboard is basically an engraving process, relying on an incised line to produce the image. Prepared scratchboards, in smooth or textured surfaces, may be purchased but are rather expensive, and because they are brittle it is advisable to mount them on a heavy backing board before inking the surface. Suitable boards can be made in the art room by coating a piece of heavy cardboard (illustration board, railroad board or folio board) with several layers of gesso, fine-sanding each coat a bit to keep the surface smooth. When dry, apply a coat of India ink with a large soft brush (maybe two coats will be needed). When dry, the board is ready to use.

Any sharp tool, needle, pin, stick, paper clip, knife, point of a circle-making compass, empty ball-point pen or sgraffito knife can be used for making the lines. Multi-lined engravers and even dental tools are excellent line-makers. Amount of pressure and kinds of tools must be tried on a scratch-scratchboard to determine best techniques and results. The scratching will reveal a light line on a dark ground — the reverse of most drawing processes.

If large white areas can be predetermined, they need not be covered with ink, but can be left white. Original drawings may be transferred to the board either before or after inking. These lines may be placed on the inked surface with a soft pencil, but will be difficult to see. The drawing to be cut should be planned ahead and sketched rather completely. After confidence is gained, the board can receive more spontaneous and direct scratching. All the methods employed in pen and ink work (stippling, crosshatching, line and textures) may be used on the scratchboard.

Scratchboard *effects* can be obtained by coating a white paper or board with a heavy layer of black wax crayon and scratching lines through the wax, exposing the paper underneath. The crayon etching method shown earlier is a scratchboard technique.

Scratchboard and pen and ink applications, because of their linear black and white quality, are frequently used in illustration and advertising design techniques. Their use is gradually declining in these areas, however, as contemporary photographic techniques can produce similar effects. Yet they remain important developments and techniques in the total graphic scheme, and are worthy of some exploration and experimentation.

1 *Dramatic value contrasts and textures are produced by scratching white areas and lines into a black surface. This guitar player was done on a 11½ x 9 inch board, at Wheaton High School, Wheaton, Maryland.*

2 *Insects and plants were subjects of these small scratchboard studies. About 6 x 8 inches in size, they are from Lutheran High School, Los Angeles, and were done on boards prepared in class.*

3 *Multilinear tools, used in engraving processes, can be employed to mark the surface of a scratchboard, as in this driftwood study. Dental tools might also be effective. The small work (7½ x 7½) is from Wheaton High School, Wheaton, Maryland*

2

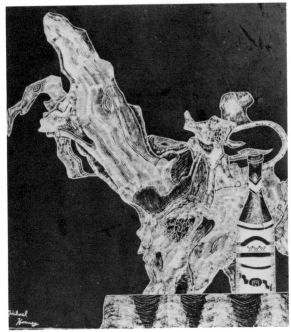

3

COLOR AND DRAWING

Drawing is usually considered a black and white art form (or maybe sepia and some earth colors). However, several of the media do include bright colors. Wax crayons, pastels, colored chalks, inks, markers, and pencils, ballpoint pens, watercolor, acrylics, and colored papers used in collage can be handled with drawing techniques to produce exciting graphic images. Using these techniques and media, the product is considered either a drawing or a painting. And even then, there might be differences of opinion. Watercolors, for example, can be used as a sketching (drawing) medium or as a full-fledged painting medium. If it is handled like other drawing materials (in a linear fashion, for example), it can be a drawing medium. So it is with the other media mentioned above.

Some painting media, acrylic, watercolor, tempera, oil, may be combined with drawing media, ink, pencil, charcoal, to produce mixed media drawings. Some of these combinations are shown on the next few pages, others are shown in black and white throughout the book. If you feel you could use color to liven up your drawing experiences, try some of these for a change of pace.

Color and Wax Crayons

The familiar wax crayon can be used as a back and white material or as a full color drawing experience. You may like the effects it has on smooth papers or textured surfaces. The sides of the crayon can be used to cover large areas or the points to work detail. Textures can be picked up with rubbing techniques. And, the waxy crayons will create resists when washed over with watercolor or diluted inks. Refer to the wax crayon section of the book for more techniques and suggestions. If you wish to work in color, this is an excellent place to start.

The rough texture of pebbled mat board is the ground for a colorful and decorative crayon drawing (card design by the author). Watercolor washes, some ink lines, and a little scratching increase the textural quality and help delineate certain shapes.

Textures are picked up by rubbing crayon over papers which are placed on textural surfaces. Some of these are cut into shapes and glued to construction paper to form an animal shape. Blue yarn outlines the various parts of this imaginary animal. Lutheran High School, Los Angeles.

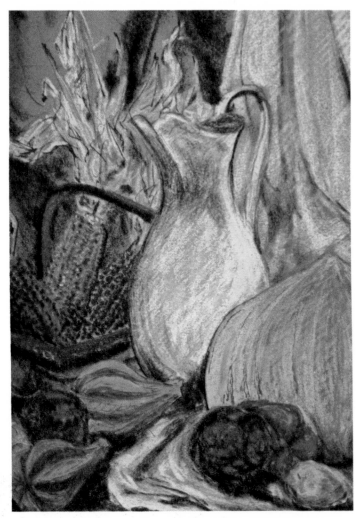

Color and Pastels, Chalk, Pencils and Other Drawing Materials

Some of the dry media, pastels, colored pencils and chalk, are available in a wide range of colors and are designed to produce colored drawings. Pastels and chalk are very dusty and need to be sprayed with a fixative to preserve them. Chalk can be combined with starch to produce a textured surface. Historically, pastels have been considered as painting media and books on pastel techniques often include "painting" in their titles.

Colored pencils have been used for many years, and some companies have developed several types of *leads*. However, not many fine artists have employed them in their work. Recently, there has been increased interest in their use. Using those colored pencils, artists are capable of creating subtle shading and carefully detailed drawings. Although sets are sometimes very elaborate and contain a mutitude of pencils, you can produce excellent results with a few basic colors.

Some non-art or non-drawing materials, such as colored stamp pads or printing inks, might provide experimental materials for you to try. Use repeated prints, fingerprints, cardboard edges, or bits of wood or erasers, to construct a drawing. Can you think of ways to combine such experimental media with regular drawing materials?

Pastels are applied to gray charcoal paper in this 24 x 18 inch still life. Some pastel drawings can be very smooth, but this student allowed the lines and marks to remain visible. Lutheran High School, Los Angeles.

This delightful and fluffy dog is drawn by repeating finger prints, inked on a stamp pad. To get the lighter values, the finger must be blotted first to remove part of the ink. California State University, Fullerton.

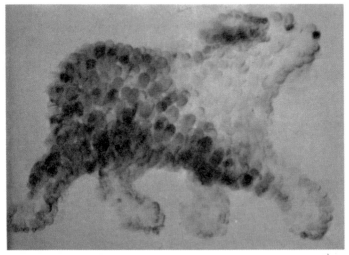

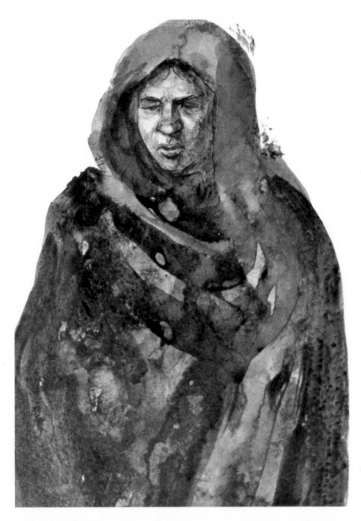

Color and Washes

Ink, watercolors, and acrylic paints can be diluted with water to produce washes of various intensities. These brushed-on areas of color can be effectively combined with lines to create exciting colored drawings. The amount of color may vary from a few small areas to a complete covering of the sheet. It may play an incidental role in the drawing or may be the most important part. It may also vary from monochromatic (only one color) to a full range of spectrum colors.

Washes can be applied with brush to the paper first to block in large areas in a generalized way. This would be followed with drawing done in ink or markers. Colored washes may also be applied later, after lines have been sketched. Both techniques are good ways to work, and you should try both to see which seems more comfortable to you.

Colored washes can be combined with pen and ink, stick and ink, pencil, charcoal, or crayon. Lines can be added when washes are still wet or after they are dry. Every combination or technique will produce different results and you should experiment to see how they work for you.

A few lines sharpen the facial detail in Charles White's sepia wash drawing. However, the washes of various values are used to create a feeling of form in both the face and the bulk of the figure. Courtesy of the artist.

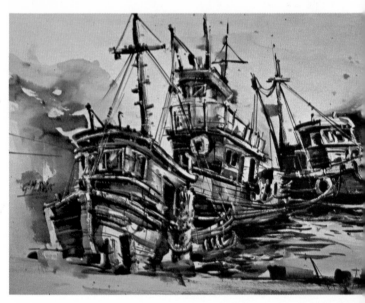

Several sepia washes are brushed on first. Guenther Riess then uses lines, produced with brushes, sticks and pens, to draw into the wash area. White lines are scratched through the washes. Collection of the author.

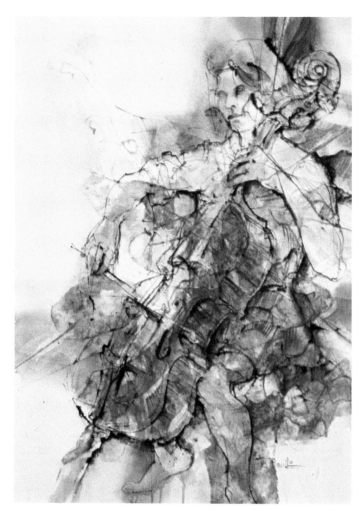

Color and Inks and Markers

Inks and pens are available in a complete range or colors, as well as black. A pen and ink drawing may be done with colored inks, rather than India ink only. Ballpoint pens can be employed with a full range of color, using the same techniques you would use for a single-colored drawing.

Recently developed markers come in a fantastic array of color and commercial artists are finding many ways to use them. Entire books are available which detail many techniques that use colored markers. Some markers are wide while others produce hair-thin lines . . . and there are many thicknesses in between. To get the entire range of colors in some brands would be extremely expensive, but you can produce very effective colored drawings with only several selected colors.

Look through the section on pen and ink and self-contained pens, and notice the many types of drawings done with these tools. Now use your imagination and think in full color. How can these be translated from black and white into glowing color?

Color should not replace black and white drawing techniques; it should be used to add further dimensions to your visual expression.

Watercolor washes of various hues provide color and texture for Lawrence R. Brullo's searching ink lines. Notice the quality of the lines (thin, thick, light, dark, weighted, intermittent) in this single work. Courtesy of the artist.

A pen and ink drawing of a student's closet is enriched with the addition of several watercolor washes. Los Angeles City Schools.

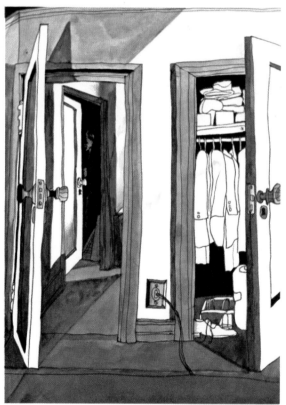

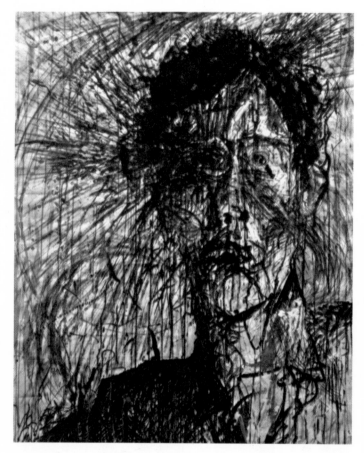

Colored inks, pens, brushes and sticks are used to develop a richly complex surface in this student drawing. Los Angeles City Schools.

A wide range of colored inks are used with fine pen nibs to create the feathers of this brighty colored bird. This detail of a larger drawing shows that dark ink was spattered in places to give the illusion of shadow and form.

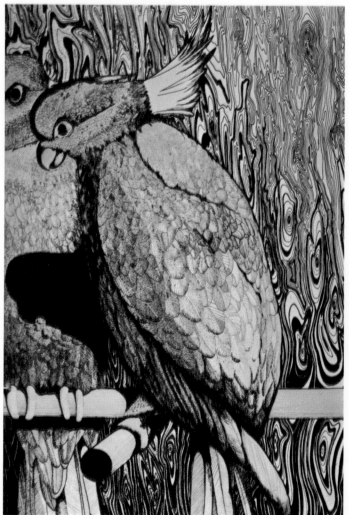

Colored markers are used in this series of overlapping gesture drawings. Can you think of other drawing styles and techniques where the addition of color might add sparkle and brightness? *California State University, Fullerton.*

Al Porter uses colored markers in selective areas to brighten this drawing in his sketch book. Notice how the simple directness of his lines contrast with the more compete drawing of the shirt. *Courtesy of the artist.*

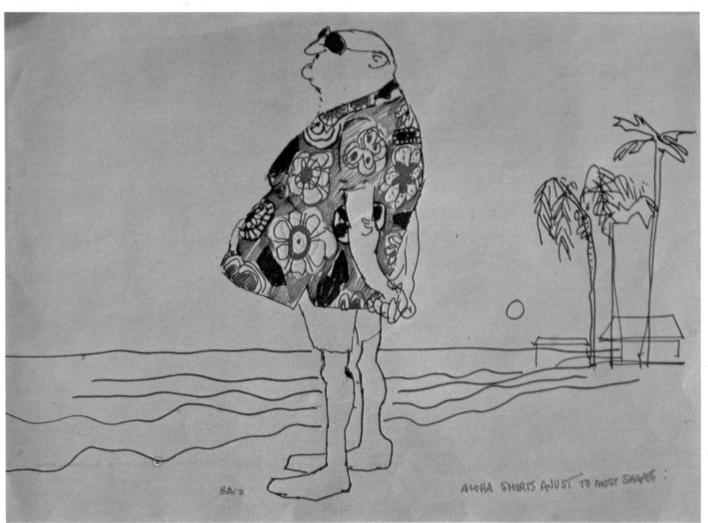

ALOHA SHIRTS ADJUST TO MOST SHAPES

Color and Collage and Mixed Media

Monochromatic drawing media can be turned into instant color work with the addition of collaged papers. Transparent tissue papers, like colored washes, can be used to cover large areas. They will allow previously drawn lines to show through. Opaque papers can be glued down first in generalized shapes, ink lines can then be brushed or drawn over them. Combinations of transparent and opaque papers can offer still more possibilities. With such collage additions, simple line drawings can seem very complex.

Many of the painting media, acrylics, oils, watercolor, casein and tempera, can be combined with inks and various tools to create exciting mixed media works. Whether the results should be called drawings or paintings is debatable. But, drawing can be a very important part of such mixed media work. It can also provide a chance for some exciting experimentation and the use of brilliant color in your drawings.

The lines are dark, but a colorful drawing is produced when various papers are collaged to the surface. California State University, Fullerton.

The use of collaged papers of various colors and textures provides a rich ground for simple contour drawings of hands. Several colors of ink also add to the complex feeling of these simple drawings. California State University, Fullerton.

Crayon rubbings and drawing in light values are applied first (note the textures). Watercolor washes of darker values are flowed over the surface to create the resist effect. Black ink is applied with pen and brush to delineate some shapes and form contrast in the work. *Paul Revere Junior High School, Los Angeles.*

Reed pens, sticks and brushes are used to draw lines in this mixed media work by the author. Watercolor, white gesso and India ink are the media used in the 22 x 30 inch still life.

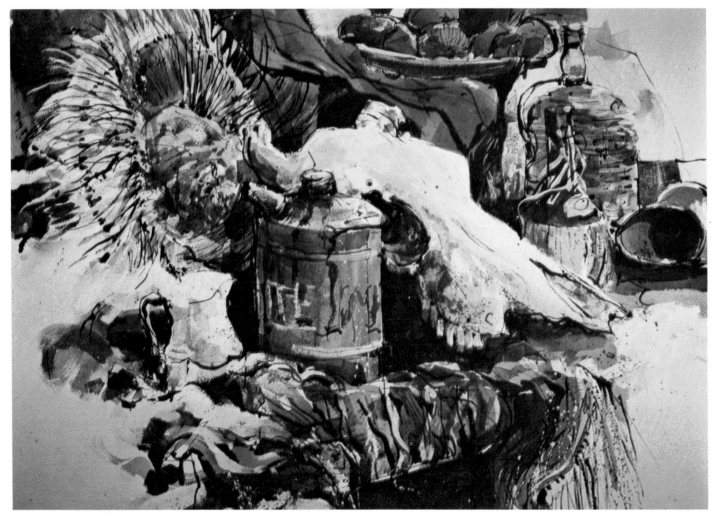

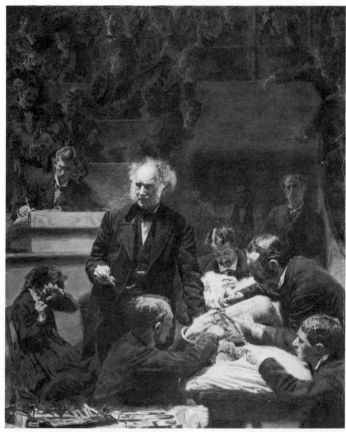

1 Mushroom, *Greg Pickrel.* Pen and ink, 10 x 12. Versatile wet media can produce juicy washes or crisp lines and dots, as in this detailed study, consisting of many thousands of dots. Courtesy of the artist.

2 Gross Clinic, *Thomas Eakins, 1875.* India ink and wash on cardboard, 25⅝ x 19⅛. Eakins produced the famous painting first, then made this masterful copy in wash and ink (the opposite of most drawing-painting procedures). Rendered with meticulous details it emphasizes the dramatic light patterns in a darkened room. Courtesy the Metropolitan Museum of Art, New York, Rogers Fund, 1923.

3 Sam Clayberger's sketchbooks contain a wide variety of subjects and media. Here he uses wet media (several washes and ink lines) to capture a landscape location. Courtesy of the artist.

4 A large loaded brush produced the washes, and a stick trailed the lines in this designed and controlled wash drawing. This sketchbook study is 11 x 14 in size and is from Granada Hills High School California.

5 Sticks dipped in ink are delineating detail on a rapidly applied wash drawing. Students are working from a model.

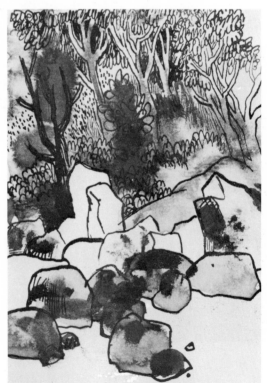

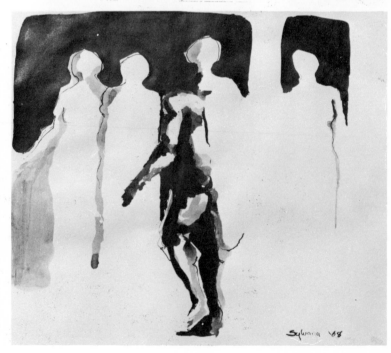

3

WET MEDIA

Trying to figure out why one artist prefers charcoal and another likes to work with ink is impossible. Perhaps the person changes preferences from time to time. Perhaps the artist feels more comfortable in one medium than another. Whatever the reason, artists undoubtedly decide on their medium after many years of searching.

Changing media might also involve a change in a personal style of working — from linear to stress on value, for example. But it is in this searching and changing that the individual approach to drawing begins to emerge. And students must experience this change in feeling toward media and subject matter. Style should not be forced on the medium, but the medium should help determine style and use. The wet media call for completely different approaches, with some materials, than the dry media. Other of the wet media (ball-point pens and felt-tipped pens) are handled much like the pencil. But steel pens, brushes, felt-tipped markers, sticks and other tools should be experienced and become part of your storehouse of techniques.

The wet media can be divided into three categories: ink, washes, and self-contained tools such as fountain pens. All of these materials, unlike the dry media, are very permanent and erasing is nearly impossible. This fact causes some changes in the approach to the drawing, because decisions often have to be made prior to putting the brush to paper. The pencil can really search and explore, with the possibility that its wayward line can always be erased. The wet media are most direct and demanding.

Included in the area of drawing with inks are the traditional pen and ink work with a wide variety of points, reed pens, and quills, using sticks and twigs, cardboard and other unconventional drawing tools. Applying undiluted ink with brushes would also fall into this grouping.

The dilution of inks with water produces liquid-like products that are appropriately called a wash drawing. Applied with either bristle or hair brushes to the paper, this method is often used in combination with pen and ink lines or other ink applications.

The self-contained ink tools now come in a wide variety, with new or improved ones appearing almost every year. Fountain pens of all types, ball-points, felt-tipped or fiber-tipped pens and

felt-tipped markers can be conveniently carried in pockets or purses, and are immediately ready for use.

There are many papers that make excellent surfaces for the wet media. A general rule to follow is that the finer the point, the smoother the working surface will have to be. The softer pointed tools (sticks, reeds, brushes) work well on softer papers such as drawing papers, rice papers, and oatmeal, construction and bogus papers. Steel pens, crowquill pens, and fountain and ball-point pens work best on harder papers such as bristol board, charcoal and bond papers, coquille, illustration and railroad boards and the harder surfaced drawing papers. Do not count any paper out until you have tried it. Like the tools themselves, papers are very versatile.

Pen and Ink Drawing

Because drawing with pen and ink resembles working with pencils or ball-point pens, which are familiar tools, this is probably the easiest introduction to the wet media. But since the resulting lines are not erasable, a different approach is necessary, one that involves more planning. Generally it is best to sketch a light framework before beginning the ink work. This, of course, varies with the problem. Inking can begin in the upper left corner and proceed toward the bottom, can begin in the center and burst toward the outer edges, or can be done in an overall manner. Use a variety of lines, solid areas, shading techniques and approaches to keep the drawing full of interest.

Steel points (nibs) came into popular use in the eighteenth century, and they nearly replaced the reed and quill pens that had been used since before the Christian era. Today, a catalog of art materials will reveal an overwhelming variety of points from which to choose, but not all of them need be used. The *Speedball* selection comes in four basic shapes: A, square; B, round; C, flat or chisel shaped; and D, oval. Each style has six or seven sizes, varying from fine to heavy. Athough designed as lettering pens, they are easily adapted to several drawing techniques, the C-6 being the finest point and the B-0 making the boldest line. Some experimenting is necessary to find which suits your current needs.

A variety of points should be available in fine, medium and heavy sizes. Traditional pen and ink work is done with fine steel points that need to be dipped often to keep a ready ink supply. Such points vary in rigidity, flexibility and the size of the point. Usually the more rigid will be most useful and will last longer than the more delicate and flexible points. Get some samples and try them out.

Very fine steel points, patterned in a hollow manner after the long-used quill points, are delicate and sensitive tools. But this very sensitiveness requires equally careful techniques. These

1

36

crowquill and hawkquill points, because of their small round shapes, require special holders.

Generally the best holder for the nibs is simply one that is most comfortable. Try several and select. They vary from thin to fat, and all points except the quills will fit any of them. Holders also come in wood, aluminum or plastic.

Pens should be cleaned carefully after use, since a build-up of dried ink has a tendency to inhibit the flow of ink. Commercial fluids are available to clean points if they become clogged. Scraps of absorbent paper (paper toweling) make excellent pen cleaners.

In reality, inks come in liquid, paste (printing) and solid (sumi) forms, but only the liquid type will be discussed. Early inks were made from oak galls, treated with iron salts and air cured, producing a dark liquid. The reddish brown bistre, popular in Renaissance times, was made by collecting the soot from burned woods and making a solution. Sepia inks were made from cuttle fish excretion. India inks, made with lamp-black (more soot) were introduced in the nineteenth century.

Two basic types of ink are available: *waterproof,* which is nearly indestructible, and *soluble,* which can be washed away if desired. Both can be diluted with water if such a need exists. There are a variety of black inks alone, and many colored inks can be used in all the areas described above. Special inks for working on special surfaces (acetate or film) or with special colors (gold, silver or white) are available today.

Steel pens work best on hard surfaced papers, while softer papers give fuzzy effects that might be desirable at times. Generally, the finer the point the smoother the surface will have to be. Try several papers before deciding which to use, and have small swatches available for trial with different points.

It is helpful to have blotting paper or paper towels handy to pick up excess ink that might happen to spill or drop unexpectedly from the pen.

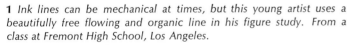

1 *Ink lines can be mechanical at times, but this young artist uses a beautifully free flowing and organic line in his figure study. From a class at Fremont High School, Los Angeles.*

2 *Pen lines faithfully reproduced the grain in this piece of driftwood. Drawing paper is the ground for this 12 x 18 study from John Marshall High School, Los Angeles.*

3 *Sam Clayberger uses pen and ink to explore a possible new direction in his sketchbook. Courtesy of the artist.*

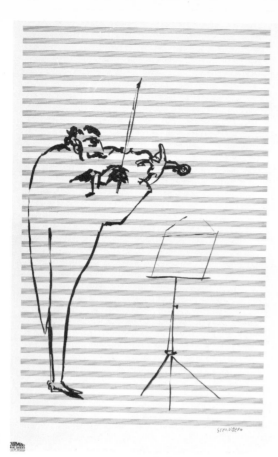

1

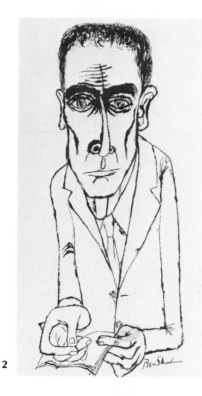

2

Brush and Ink Drawing

There has been a much longer history of brush drawing in the Orient than in Western cultures, because the brush was also the most important writing instrument. The *sumi* techniques made use of the same brush manipulations and ink supply that were used in writing. The calligraphic line and the dynamic shapes that easily flow from the loaded brush make it at once a most exciting medium and a difficult technique to master.

Chinese and Japanese brushes are still valuable tools when working with ink. Several kinds are available, most having bamboo handles and coming in a normal variety of sizes from 000 (smallest) to 6. Their hairs are longer than watercolor brushes, hold more ink and come to a very fine point. If the brush is held in a vertical position while working, a line can be varied dramatically with a slight change in pressure on the paper. Although Chinese brushes are highly recommend for brush and ink work, any watercolor or bristle brush provides its own texture and feel to the work.

The traditional sumi ink comes in stick form, and in this way has been manufactured in China as far back as 2500 B.C. Usually, like wine, the older the sticks are the better the quality of ink. The sticks are rubbed down with water on stone blocks or troughs, and the resulting ink has a wonderfully smooth appearance and is easily diluted to make washes of infinite variety. India ink, much more readily obtainable in convenient jars, is the most suitable ink to use in schools, even though less romantic. Black watercolor, diluted black tempera or diluted oil paint may also be used with interesting effects. Colored inks can also be used, but the product might then be more easily referred to as a painting than a drawing.

A textured line or tone can be achieved by using a brush from which much of the ink has been removed or blotted. The *dry-brush* technique can provide exciting textures and subtle tones when handled carefully, especially when applied to textured paper.

A blotter placed over a fully loaded brush line or shape will produce beautiful textures or tones. Experiment with blotters, drawing papers, diluted inks and brushes for best results.

The size and kind of papers should be varied, as each provides a new graphic experience. Smooth papers give sharp contours and rough or absorbent papers tend to provide a softer edge. Rice and blotting papers are very absorbent and give beautiful records of the ink and the pressures of the brush. Try a loaded brush on dampened paper and watch the creeping effect. With a little practice, a wide variety of effects as well as bold lines can be handled with ease.

Brush drawings can be finished works in themselves, value studies for other drawings or paintings, or make excellent subjects for woodcuts or linoleum prints. The calligraphic effect of brush drawn lines, done freely and with sensitivity, provides some of the most brilliant linear passages in drawing history. However, relatively few people have truly mastered the medium.

1 The Violinist, *Saul Steinberg.* Pen and ink on music paper, 21¼ x 13½. The artist's selective line (including only essentials) is graphically placed against an appropriate prepared paper (including the Schirmer trademark in the lower left corner). Collection, Fogg Art Museum, Harvard University, Cambridge. Bequest of Meta and Paul J. Sachs.

2 Dr. J. Robert Oppenheimer, *Ben Shahn, 1954.* Brush and ink, 19½ x 12¼. Shahn uses a crabbed line to delineate his caricatured figure of the noted atomic scientist. Collection, The Museum of Modern Art, New York.

3 William Pajaud uses a smooth, free flowing brush line that sometimes trails from the tip of the brush, but at other times relies on heavier pressure. Such a sure drawing line comes only with much practice and careful observation. Courtesy of the artist.

4 Expressive faces seem literally to flow from ink-loaded brushes.

5 The student model was drawn completely in a dry brush technique in this large 34 x 24 inch work. A bristle brush, partially blotted dry, was used with black ink. Black tempera might also be employed. Hollywood High School, California.

4

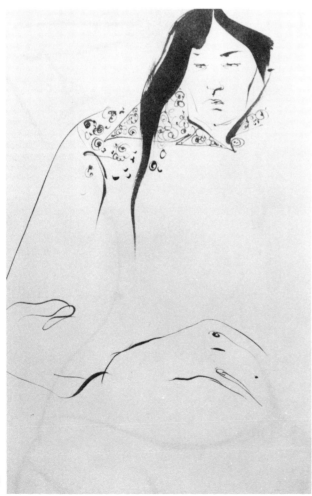

3

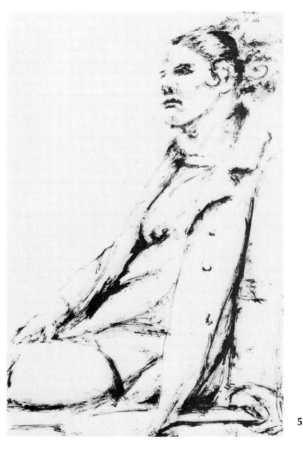

5

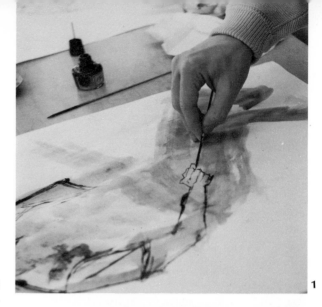

1

Reeds, Sticks, Twigs, Etc., and Ink Drawing

In an age of exciting experimentation, an ingenious artist might sharpen a goose quill (if he could find one) or a reed, and think he has discovered a new drawing tool. But such natural materials were used for drawing with ink since the Middle Ages. During the Renaissance, nearly every artist used reeds and quills, along with brushes, to apply ink to paper. All through history people have tried to use ink with new and innovative materials. Any school art room might turn up something new.

Quill pens, cut from the large wing feathers of fowl and birds, were among the earliest pens used and produced a flexible and responsive point. *Reed pens,* cut from the hollow reeds growing along rivers, are a more rigid drawing tool. The fibrous material, cleaned and cut, is best used for short drawing strokes since the soft woody material absorbs ink easily. But this very quality, especially when applied to soft papers, will produce exciting results. Vincent van Gogh made extensive use of reed pens, either by themselves or with quills and steel points. Oriental bamboo reed pens are available from art supply dealers, most of them coming with a Chinese or Japanese brush on the other end.

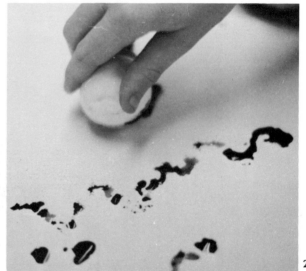

2

Much experimenting can be done with a variety of wooden sticks on various papers. Each stick will have its own feel and each may be sharpened to a point that is best suited to the need. Applicator sticks, available from medical supply houses, are long and flexible and make excellent drawing tools. They can be twisted and turned in the hand to produce an organic line, and can be laid down almost flat to make wide strokes. They can be handled like a dry brush to make textures and can be sharpened to a fine point to make hair-thin lines.

Try twisting a popsicle stick to splinter a point. How about a toothpick? Sharpen a chopstick or brush handle and see what happens. Francis de Erdely produced masterful drawings using a balsa wood stick held in a variety of ways.

Most wooden sticks need to be sharpened to an obtuse point with a knife or razor blade, because if cut too thinly, the wood will soften and almost make a brush-like line after working for a while (which might be just what you want). Soft papers, such as drawing, bogus or oatmeal papers, provide excellent grounds for stick and ink drawings.

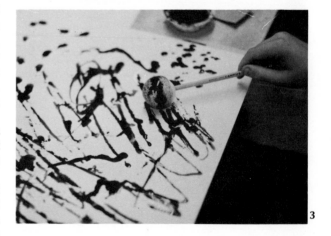

3

4

Nature provides a more immediately available drawing tool than the quill or reed, which must be cut to a point. *Twigs* and thin branches can be used just as they are found. Bring a bunch of them into the art room, break off the unneeded side twigs, keep everything that is about 8 – 15 inches long, and you have a box full of drawing tools. Dipping these twigs into an ink supply and drawing on soft paper or on a dampened sheet will provide a stimulating graphic experience.

Explore all avenues, if you are interested. Put ink into a tray, dip cardboard edges into it and draw. You can make drawings with ink and scrap metal, pieces of wire or bone, bits of dried leather, plastic shapes and nearly anything that can be dipped and applied to paper. Have a blotter ready (paper towel, cleansing tissue or blotting paper) to pick up excess ink or to texture large areas.

Try drawing on unconventional papers, such as sheets from the newspaper or magazines, or wallpaper, cloth, acetate, plywood or plankwood scraps, on glass or plastic sheets. There are infinite possibilities available to those willing to try them.

5

1 *A sharpened stick produces a descriptive line. Try holding the stick or twig in several ways to produce more variety.*

2 *A Styrofoam ball, looped with a length of string, provides an experimental drawing tool.*

3 *This experimental drawing uses a Styrofoam ball with a pencil holder. Dipped in India ink, the ball leaves a graphic trail of its meanderings on the paper.*

4 *An 18 x 12 stick and ink sketch on oatmeal paper makes for a design involving the Twelve Days of Christmas. The textured oatmeal paper is a wonderful ground for the sharpened stick. Lutheran High School, Los Angeles.*

5 Hollyhock, *Gerald F. Brommer. Twig and ink, 24 x 16. A twig, broken to leave a slivered end, produces an interesting organic line, very useful in describing plant forms.*

Wash Drawing

At first glance, the term wash drawing seems a contradiction, with one part of the term suggesting a painting and the other a drawing. But since the paper ground is an important part of the work and it is generally monochromatic in color, this technique can correctly be called a drawing medium. Historically it has always been so. Unlike brush and ink drawing, which relies on solid black ink application, the wash drawings provide a wide range of grays or values, because of the dilution of ink with water.

Renaissance and Baroque artists delighted in working the softness of the wash against the hard quality of a pen line. And artists yet today find the medium a sensitive one for probing and searching, or in preparation for work in other media. The basic quality that makes it popular for these studies is the ease with which values and dark-and-lights can be achieved. The spontaneity and variety of techniques that are easily learned make it a most useful and necessary part of your drawing program, especially in its many combinations with other drawing techniques.

Watercolor brushes are generally the most useful, but extensive areas of wash can be laid down quickly with large bristle brushes. The Chinese and Japanese brushes discussed previously, are also good wash drawing tools.

India ink is the most used source of value for wash drawings. A tray with several compartments, or several small containers, can be stocked with a variety of value washes — from light to dark — simply by diluting the ink with various amounts of water. Experiment. Although black is the usual wash color, earth colors (sepia, umbers or siennas) can either be used individually or mixed with black for extremely rich surface colors. Explore the possibilities.

Inks aren't the only material that can form washes. Try thinning black tempera. Or use black watercolor. Black acrylic paint can also be thinned with water and treated as a wash. Or for a completely different feel, try thinning black oil color (or earth colors) with turpentine and painting these washes on paper. India ink and watercolor are the finest grained materials and will produce the smoothest washes — but then a textured wash might be just what you're looking for, so don't pass up the possibility of an exciting change of pace.

The white of the paper is vitally important, as it is in most drawing techniques. It shimmers through the transparent washes and sings out alone when left untouched. It is the control of this untouched area, contrasting with the darker values of the washes, that makes a fresh and sparkling work.

Experiment with papers. Oatmeal, drawing and bogus papers; tagboard, Kraft paper and canvas; watercolor, charcoal and bond papers; rice papers; any and all surfaces and textures should be explored. Each can make a definite contribution to the character of the drawing. There is no "best" paper, and after trying several types, you will find the one or two that en-

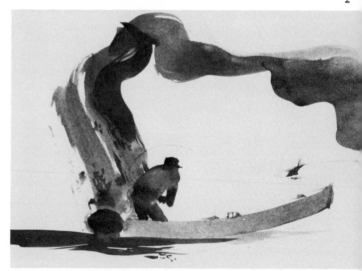

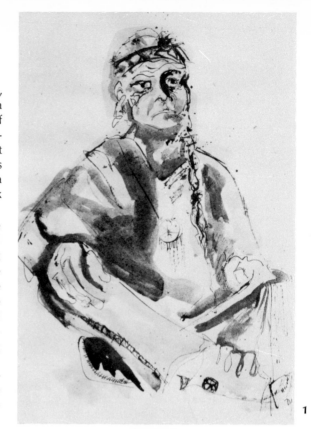

1 *Dressed up student model, sketched first with brush and wash; stick and ink were added later. Some lines ran while the washes were damp, others are crisp because the paper had dried. Spatters and spills add texture. On oatmeal paper, 24 x 18. Lutheran High School, Los Angeles.*

2 *Only a few brush strokes with washes of varying intensities are needed to make a compete statement. William Pajaud is a master at simplifying complex visual material. Courtesy of the artist.*

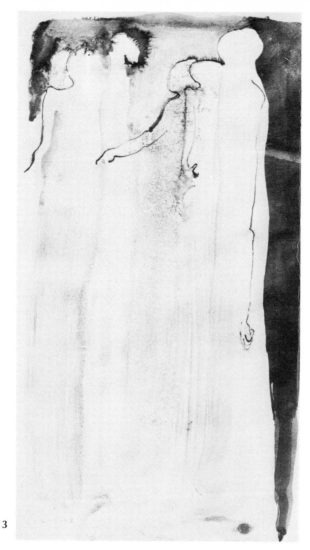

hance your style and technique of working. You will get fewer puddles and smoother washes if the paper is kept at a moderate slant when working.

Try cardboards and wood if you wish. Attempt to work on wet paper and dry. If you wonder if wash will work on a gessoed masonite panel, try it. Collage several papers together and apply washes over the result, and see how various papers absorb or resist the watery medium.

Wash drawings are seldom used alone, but often in combination with line — pen and ink, stick and ink, twig and ink, brush and ink — any kind of line. It is in the contrast between the soft wash and the hard pen line that the medium speaks best.

Observe the many examples on these pages or in the advertising found in your local newspaper. Run a loaded pen point over a wet gray wash and watch the action. Let the ink-loaded stick cut its incisive way over a dry wash and notice the contrast. Put down the lines first and then the wash. Put down the washes first, then add the lines. Work them both at the same time. Try a variety of drawing tools with the wet washes. You can dip a pen or stick into a gray wash and make a thin gray line. Scratch in the wet wash with a brush handle or dry stick and see what happens.

Before drawing a still life or a figure, spend an hour or so experimenting with ink washes and explore the possibilities of the various combinations suggested. This will eliminate some of your inhibitions and should give you a sense of freedom.

Wash drawings can be carried out in tight detail or can be applied freely to the paper. It is in the freer techniques that the medium seems to work best.

Start with the largest brushes and hold off the small sizes until absolutely necessary (if at all). This will help keep the spontaneous feeling alive in the drawing. Work freely and rapidly, allowing "happy accidents" to determine methods of procedure. If something beautiful happens in the running together of washes or lines, let it happen — and leave it alone.

Freely brushed wash drawings should be rather quickly finished, but a few touch-ups on the second day might be necessary. When the first washes are dry, the overlapping washes of the second day will be more intense than if applied to the wet sheet on the first day.

3 *Group of people are actually left, while the negative space around them was washed in. Several brushed lines indicate hands and arms. Granada Hills High School, California.*

4 *A close-up detail of a larger sketch shows how overlapping washes of several values of diluted India ink can provide the contrast needed for a complete drawing. No line was added. All the work in Al Porter's drawing was done with a large watercolor brush. Courtesy of the artist.*

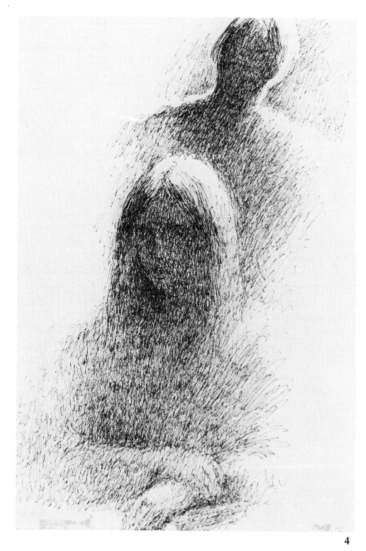

4

Self-contained Pens

Many years ago, a pen that carried its own ink supply was only a dream, and not until 1809 did someone do something about it. John Sheaffer, an Englishman, patented the first reservoir pen; and in 1884, Lewes Edson Waterman designed a practical fountain pen. But early fountain pens needed specially thinned inks in order to operate, and drawing inks with great intensity were out of the question.

Today, *fountain pens* are durable and useful and will function beautifully with specially designed intense inks. The pens come with an infinite variety of points or nibs — some for writing, but many especially for drawing and sketching.

There are also the artists' fountain pens with specially designed nibs for using India ink. These tools often come with screw-in nib units which can be changed easily and often, depending on the thickness or quality of the lines desired. Some of these fill directly into the unit, others by cartridge; all come with a variety of points.

Ball-point pens are improving constantly, and come in a wide range of styles for specialized uses. Those made for use with photocopying equipment are excellent, and come with a variety of point sizes. One make even uses India ink and has a replaceable cartridge. Many brands of ball points are available easily and inexpensively and most will do an excellent job in any color chosen. They can be used especially for sketching, while some students find them useful in making finished drawings. The inks dry immediately, and the pens with permanent inks make excellent tools in the art room.

The most recent addition to drawing instruments came in the late 1950's in the form of *felt-tipped pens,* and these have grown into an astounding number of pens with felt, nylon and various *fiber tips.* They come in an equally astounding number of colors, sizes and tips, so that drawings that approach paintings in their color and complexity can be produced without using brush or palette. Some pens are disposable when empty and others are refillable. Variety is almost endless.

1 Engine, *Guenther Riess. Ball-point on bond paper, 18 x 24. The ballpoint can provide value contrasts in areas by cross hatching or constantly overlapping line patterns until the correct value is achieved. Collection of the author.*

2 *George James works with many materials, but this house was sketched with a fiber-tipped pen, one of many types of drawing tools. Courtesy of the artist.*

3 London, *Richard Downer. Fountain pen and wash drawing, 12 x 19. The artist's familiarity with London buildings enabled him to freely sketch this perspective view. Slight washes color certain places, but the expert line has picked up enough detail for positive identification. From the artist's book* Buildings, *courtesy Studio Vista Limited, London.*

4 Figures, *Valerie Love. Ball-point pen, 16 x 10. Delicate squiggles are massed to produce a soft feeling. Squinting the eyes helps see facial features. Courtesy of the artist.*

HIERO-GLYPHS
FIDEL DANIEL

CHALKBOARD WORKS, MULTIPLE-EXPOSURE POLAROIDS,
SEPIATONE AND BLUELINE DRAWING DUPLICATES—
JANUARY 8-30, 1971 RECEPTION: FRI., JAN. 8th 8p.m.
ORLANDO GALLERY 17037 VENTURA BLVD, ENCINO, CA.

1

The original felt-tipped pen, the Flomaster, has a variety of interchangeable tips and can be refilled. Other felt-tipped tools are the many markers that come in every hue of the rainbow. Some of these produce wide lines made with squarish points and are most useful for bold sketching and filling in color areas. They are used well in connection with pencil, washes, fiber-tips and other linear tools.

The era of the fiber-tip was initiated in the early 1960s with the advent of the Japanese Pentel, a nylon-tipped pen which produces an expressive line and seems to combine the fluid quality of a small brush with the sharp quality of a pencil — especially when the point is still sharp. Most are self-contained and disposable, but several have replaceable ink units.

Most of these will draw on any kind of paper, slick or rough, and on almost every surface including plastic or glass. Most are not indelible and will smear when wet, but others are completely permanent.

The fiber-tips make excellent sketching tools and can be quite expressive. The line can be thin and clean, or if the pen is turned on its side can be thick and soft. When the points become nearly dry, they produce soft gray lines that are almost "dry-brush" (or dry-tip) in their feeling. They are superb tools for contour drawing, as the line is easily produced, no pressure is required, and the trail of the point makes a bold impression. Try turning the point in your hand while working a line — turn it around between your fingers or change its angle with the paper. Try it on soft paper and on papers with a hard surface. Sketch rapidly. Draw carefully. The fiber tips are wonderfully adapted to many techniques.

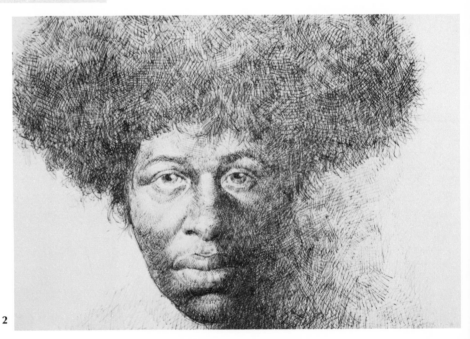

2

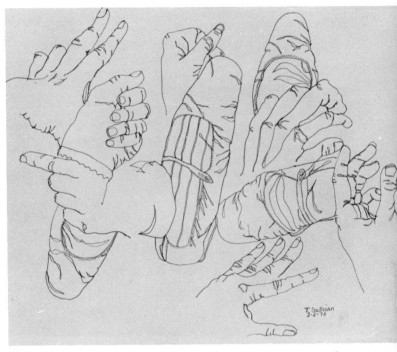

4

3

1 Poster, *Fidel Danieli. Original in felt pen, 18 x 12. Stencils were used to block out the letters, and the pen produced the cross hatched lines and dots. Courtesy, Orlando Gallery, Encino, California.*

2 Pens are used for both rough sketching and more finished drawings. *Charles White used only line to create areas of shading and produced a strong sense of form in this sketchbook study. Courtesy of the artist.*

3 A double sketchbook page was employed to hold this fiber-tipped pen drawing of a student sketching. *Los Angeles City Schools Special Scholarship Class.*

4 A violet colored fiber-tipped pen was used on 18 x 24 bond paper for these contour studies of hands and shoes. *Hollywood High School, California.*

1 *Both wet and dry media plus collage were used to dramatize this drawing of a doll. The work used pencil, ink, charcoal, some watercolor washes, and collaged papers. It is 24 x 18 in size, and from Reseda High School, California.*

2 *A drawing based on one of the zodiac signs, pisces, makes use of Pentel, pen and ink, and collage in a sophisticated composition. The 18 x 24 work is from Paul Revere Junior High School, Los Angeles.*

3 Pier and Ocean, *Piet Mondrian, 1914. Charcoal, brush and ink, heightened with white wash, 30 x 40. Done during the artist's "plus and minus" period, the large drawing was in preparation for a later painting. Each material was used for what it does best. Collection, The Museum of Modern Art, New York, Mrs. Simon Guggenheim Fund.*

4 Man with a Hat, *Pablo Picasso, 1912. Pasted paper, charcoal and ink, 24½ x 18⅝. Charcoal produced the lines, the ink provided the values and the morning paper contributed the collage. The work is in the cubist style which the artist pioneered. Collection, The Museum of Modern Art, New York.*

4

MIXED MEDIA

It might seem that combining several materials in one drawing is a recent or even contemporary addition to the art scene, but this is not so. Since Renaissance times, and perhaps before, artists have used materials in combinations to obtain certain desired effects. "Brush, pen and ink over black chalk, heightened with opaque white tempera, with a little gray wash, and touches of pink and yellow pigment." Contemporary? Hardly, since the artist, Bernardino Gatti, lived in Italy from 1490 to 1576, and the small drawing was a study of an apostle.

Some artists prefer to work in a single medium, bending and making it fit under all circumstances, while others like to use a variety of media in various combinations to obtain the proper surface or feeling in their drawings. Since invention and exploration are key words today, combining materials seems attractive to many. Artists and students are trying, experimenting and mixing a great number of drawing materials to get stimulating and exciting results.

Mixing media generally produces richer surfaces and more complex drawings. But consider that drawings are essentially linear in structure; and adding various washes, brushwork or textures should only increase the drawing's impact and/or enrich its surface. These additions should not produce a painted surface or obliterate the graphic features of the work. The combining should be purposeful, its goal being to present a richer image, to show a contrast of materials, or to express more completely the concept of the artist.

Paul Klee experimented freely with mixed media, as did his contemporaries in the German Bauhaus and much of their inventiveness inspires our current drive toward trying all available media combinations. A catalog of Klee's work reveals a range of materials (and this only in part): vaporized watercolor and brush on cardboard, watercolor and oil on paper, batiked paper with watercolor, chalk and ink on blotter, watercolor and wax on linen, and watercolor over chalk on paper set on gauze backed with cardboard. He experimented as freely with his grounds as with his media.

Try dry materials together, wet media together or wet and dry materials together. Work soft materials against hard: wash against pen, charcoal against pencil, pencil against steel pen. Try working dark against light; brush and ink against wash, charcoal against tempera, wash against gesso. Experiment on various

4

1

grounds: paper, cardboard, cloth, blotters, collages. Work large, small, loose, tight. Try all sorts of mixes to see what best fits individual working habits, or the subject of the drawing.

You cannot possibly work all the combinations available — they must run into the hundreds — but a bit of experimentation can add greatly to the artists' drawing experiences.

Mixing Dry Media

Dividing the mixed media into dry, wet, and wet and dry combinations is only for the sake of organization. No special sequence is suggested; but literally — mix them up.

If we take the five dry media (pencil, charcoal, chalk, conté crayon and wax crayon) and try to figure the number of combinations possible, we can get twenty-three. For example; pencil and charcoal; pencil, chalk and wax crayon; or pencil, charcoal, conté crayon and wax crayon. If we add a bit of collage to each one, we can have forty-six combinations; add a bit of one of the wet media (ink) and get ninety-two possibilities. In short, there are too many to be concerned with, so select any two.

Try working a powdery material with a waxy one. Use a soft edge charcoal with a hard edge pencil. Use the sepia color of a conté crayon with the rich black of a charcoal stick. Within the dry media alone, a vast range of combinations and effects can be experienced.

And try each on different papers. Charcoal and black crayon will give dramatically different results if drawn on bond paper and then on oatmeal paper. Look at the combinations of dry media illustrated. There are many more.

1 Figure, *Corinne West. Pen, brush and ink, and collage, 16 x 12. Fantastic textural areas were produced on separate papers, torn into shapes and glued to the surface. The beautifully drawn face was done in pen and ink. Pen lines and doodling tied the work together. Courtesy, White's Gallery, Montrose, California, and the artist.*

2 *Drawn from a photograph, this old man is done in pencil and charcoal on drawing paper. Charcoal areas were softened by rubbing with a paper tortillon. The white of the paper is very important in this 16 x 14 drawing. Lutheran High School, Los Angeles.*

3 *Powdery charcoal and waxy crayon were used together in this spontaneous but large (34 x 22) drawing from life. Hollywood High School, California.*

4 *Not two media but two hands were used simultaneously in this drawing. Each hand held a crayon (one red and one blue) and carefully sought out the contours of the chair and desk grouping. Shading was done later. Reseda High School, California.*

2

3

4

51

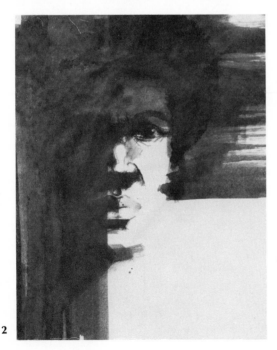

1

2

Mixing Wet Media

Soft and liquid passages of washes are beautifully set off by the severe sharpness of a steel pen, but even this harshness is softened if the paper is damp. The organic thick-and-thin line produced by a stick dipped in ink is in sharp contrast to wash and tempera areas brushed down beneath it, or over it.

Begin with a pale India ink wash on drawing paper. Add darker passages with more intense washes. Run a stick and ink line through the damp areas and draw crisply on the dry sections. Lighten some parts with white tempera. Gray the tempera with a bit of ink. Add more washes, line, tempera, and some sepia ink in certain areas. Dry brush some textured sections. Take a fiber-tipped pen and add rapid action strokes. Follow with more washes and stick and ink. Add some spatter with a toothbrush dipped in wash. Some more washes brushed on and it is finished. You have witnessed a step-by-step drawing carried out with a mixed wet media.

Try thinned oil paint or asphaltum as a drawing medium. Work on canvas, paper or gessoed boards or panels. Try shellac or lacquers over ink lines or washes. Mix Pentels and washes together (most fiber-tipped pens use water soluble ink and interesting smudging takes place when washes hit the ink) or try colored inks with black tempera or India ink lines.

Enriching the surface of the ground produces beautiful results when using the wet media. Collage white papers together on illustration board. Collage textured paper toweling or various rice papers on a folio board, and work washes and lines over the surface. Gesso a masonite or chipboard panel and use ink washes, oil or asphaltum washes over the heavily textured surface.

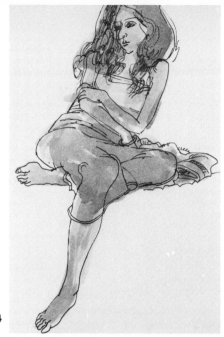

1 George James combined pen and ink and brush and ink for a dramatic composition. The strong dark areas in negative spaces tie together the fragmented parts of the sketch. Courtesy of the artist.

2 Gray washes and several felt-tipped pens were used in this dramatic drawing. Both dark and white backgrounds eat into the face, which reveals careful observation. The Los Angeles City Schools Special Scholarship Class.

3 Washes blocked out the general shapes, then brush and stick lines were added for detail. The work is 23 x 27 in size, and from Granada Hills High School, California.

4 Sam Clayberger combined the soft shading quality of colored markers with the hard line of pen and ink in this study. Courtesy of the artist.

4

3

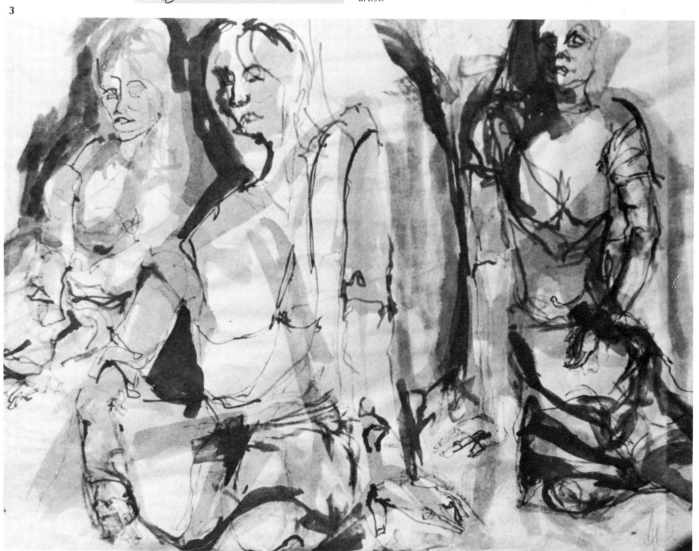

1

Working with wet media alone can produce a wide range of textural and linear contrasts. Apply them to collaged surfaces and the number of possibilities is doubled. Experiment with using old toothbrushes instead of conventional brushes.

Try submerging a heavy paper in a tub of water, drip white areas will appear. Outline these with a pen; draw paper out of the water and watch the action on its surface. When the paper is dry, use it as a ground for some type of brush or stick and ink line.

Take a sheet of slick white paper (like finger painting paper) and apply some loaded brushfuls of wash to it. (Colored ink washes may be added.) Place a second sheet of slick paper over it, press in all directions and quickly separate. Instantly, there is another surface on which to draw with other tools, or to use in a collage.

Do not let such interesting surfaces control the drawing. When line is applied, it can be kept independent of the shapes on the surface; or, the shapes formed might suggest a drawing.

Or try some *resists*. Apply rubber cement in patterns, and when dry, lay loaded washes over the surface. When these dry, remove the rubber cement by rubbing with your finger, and patterned white areas appear. Outline these with a pen; draw in them with a pentel; or let your imagination conjure up an image to work over the surface. White glue will also cause a kind of resist but cannot be removed and will leave a ridge — which might be fine.

Try a *tempera resist*. Make a light pencil sketch of an object. Apply white tempera in solid masses where highlights will appear, and dry brush tempera where you wish a middle value to be shown. When completely dry, apply India ink with a soft brush over the entire image. When that is dry, wash the sheet under warm tap water to remove the tempera. Tack the sheet up to dry. The textures which appear can be retouched with India ink and brush or pen, or can be left as they are.

Experimentation can produce endless surfaces on which to draw with other wet materials; or the experimentation can be an end in itself.

1 *Wide colored markers and pen and ink (or fine-tipped markers) combine nicely to make interesting statements. Either can be put down first, depending on the materials and your way of working. Student drawing is from California State University, Fullerton.*

2 Alamos, Mexico, *Gerald F. Brommer. Wash, stick and ink, 11 x 14. A quick sketch, blocked out in wash with various stick lines for selective detail and texture.*

3 *This wash drawing was combined with a tempera painted background, of completely different feeling, for an interesting pop art effect. It is 24 x 18, and from John Marshall High School, Los Angeles.*

4 *A seated skeleton posed without moving for this 24 x 18 wash drawing, with pen lines added. Gardena High School, California.*

2

3

4

Mixing Wet and Dry Media

Since the time of the Renaissance, artists have been mixing wet and dry media, each for its own special effect. That is still the case. If you make a list of dry media (pencils of all types, charcoal, chalk, conté crayon, wax crayons) and add to it a list of wet media (washes, India ink, tempera, oil, asphaltum, acrylics, casein, colored inks and a variety of pens and tools), the number of possible combinations appears endless. No attempt will be made to illustrate or list them all.

If you have available a range of contrasting materials, you will be encouraged to mix them while your drawing is underway. You will soon be able to decide to use wash where it is needed, and charcoal where it works best.

Try to use contrasting materials for best results. Work powdery charcoal or chalk against smooth washes and the crispness of a twig-and-ink line. Or work black wax crayon over a gray tempera area to heighten texture. Draw with a heavy pencil over smooth washes or use felt-tipped markers over liquid-like areas. Spatter and stipple, scratch and scrub to use the media fully, producing exciting results.

3

4

1 Observation, Valerie Love. Pencil and pen and ink, 14 x 20. The crispness of the pen line is played against the pencil to produce a most interesting study. Courtesy of the artist.

2 Pencil not only was used for sketching, but also became an important part of the finished work. Watercolor washes provided value and the heavy dark lines. Fremont High School, Los Angeles.

3 A student model is drawn in ink, tempera and pencil, with collaged newspaper added. All was done on brown kraft paper at Gardena High School, California.

4 Contour drawing in pencil (dry) is outlined with fiber-tipped pen (wet) and shaded slightly with pencil (dry). Dana Lamb developed a unique form of expression. California State University, Fullerton.

5 The model was sketched in ink on oatmeal paper. The sides of black crayons were used to produce the value contrasts.

5

Water and Wax

Perhaps some of the most interesting textural surfaces in drawing are obtained because of the antipathy of water and wax. Since they do not combine, they resist; and when wax is applied to paper, washes put over it tend to run off and settle in the unwaxed areas. This process is called *wax resist*.

Draw vigorously with a white candle on a sheet of white paper. Apply a light wash over it and observe the patterns that form. When these are dry, draw with more wax over the washes and apply darker washes. The surface becomes richer and richer, the more the process is repeated — up to a point. This design can be drawn into and over with a steel pen or a pencil. Try a variety of approaches, abstract or representational.

A *crayon resist* is very similar. Draw and apply colored crayons heavily to a paper, and flow ink or watercolor washes over this. Work back into the drawing with more crayon and more and darker watercolor washes until the results are satisfactory.

Work on large sheets of brown Kraft paper with crayons, pencils and white candle wax. Brush areas with India ink or watercolor washes. Work more with crayon and wax and wash.

Scrub and scratch and manipulate the surface for varied results.

Rubber cement and PVA glue resists work on the same general principal, but are not as versatile as the wax resist techniques. Try them and see what can be done.

1

2

1 *This shows an exploratory study to delve into textural possibilities of wax and wash techniques. First wax patterns were applied with a candle, then wash, more wax in different patterns over the dry wash, more wash, more candle, more wash, until the desired richness was achieved. Stick and ink line was added from time to time. The fish is 14 x 20 in size.*

2 *Large crayon and wax resist drawings are often best done on the floor. This one is on 30 inch wide brown kraft paper.*

3 *Al Porter first draws with a block-out material (rubber cement or Miskit) on white paper. He then lays down large, soft washes of several values. After removing the block-out, he finishes by drawing with pen and ink. The entire process creates an active and intricate surface. Courtesy of the artist.*

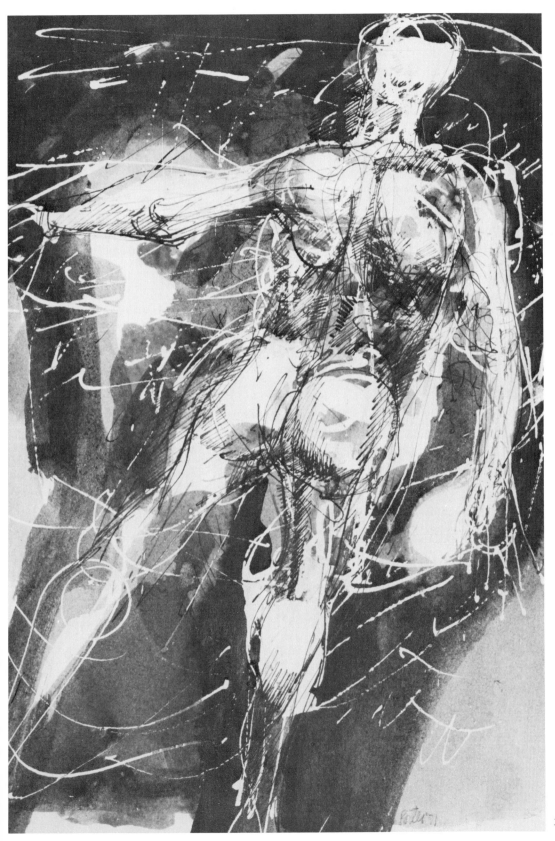

3

Experimental Mixing of Media and Tools

One of the strongest characteristics in the art of our time is the desire to break from conventional ways and explore new materials and techniques. And drawing is not immune to this excitement and change. Many new materials, pens, markers, inks, paints and grounds are available. But probably the experimentation done with conventional materials in unconventional ways is the most challenging.

An example of this is an ink drawing done with a palette knife. Try pouring some ink on a sheet of hot pressed illustration board or any resistant paper. Manipulate the ink with a knife, draw in it with a toothpick, scratch it with a toothbrush or comb, blot it with crumpled paper or facial tissue — and observe the results.

Try applying other conventional materials in new ways, as drawing heavily with crayon on plywood and hitting the surface with a torch. Fill a squeeze bottle with white glue colored with India ink or black tempera, and trail the material in a contour-like line drawing. Or mix white tempera with white glue and trail on a sheet of black railroad board.

Draw on plywood sheets with washes and ink. Four by eight foot drawings can be done this way. Or take a small cube of wood and draw on it. Make a papier-mâché face and draw in the features. Prepare a three-dimensional gessoed surface and draw on it with pencil, much like the contemporary shaped canvas paintings. Take ready made surfaces — walls, old busts, manikins, anything — add one or two coats of gesso if desired, and begin work with pencils.

Try drawing with some materials on clear plexiglass and view the drawing from both sides. Or take a clear plastic cube and draw on all six sides, then turn the "drawing" around in your hands to look at the overlapping and combining images. Draw on several layers of clear material and place them over each other — or motorize them to combine in various ways at different times.

Check local manufacturers for products, materials or by-products that you might obtain reasonably. Often parents of classmates or friends can supply unconventional "art materials" from their jobs or businesses that can stimulate classes into fruitful experimentation.

Look at the decorative drawing on some autos or vans, or the grafitti on some walls. Contemporary artists and students are experimenting with the oldest and newest materials in some unusual combinations. But they are drawing.

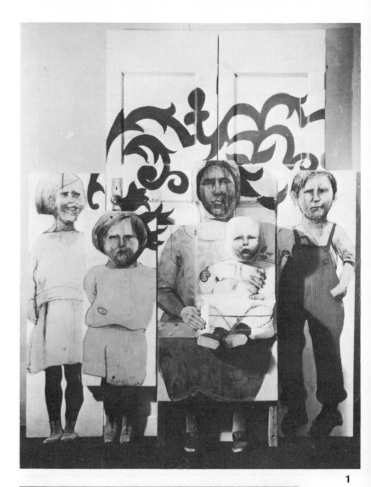

1

2

60

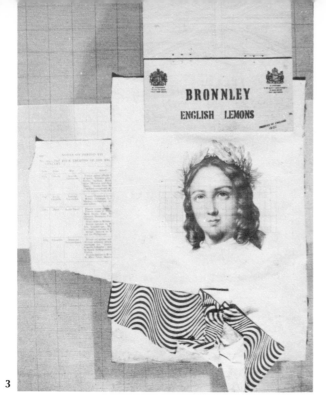

3

5

1 The Family, Marisol, 1962. Wood with paint, charcoal, plaster, pencil and other materials, 82 x 65 x 15. A large assemblage, the work on the faces is chiefly drawing, on both the carved and flat surfaces. Collection, The Museum of Modern Art, New York, Advisory Committee Fund.

2 Sculpture Drawings, John White. Colored felt markers on enameled wood, each 4 x 4 x 16. The artist's movement studies are adapted to three dimensional surfaces. Courtesy, Orlando Gallery, Encino, California.

3 English Lemons, Don Lagerberg. Pencil, ink and collage, 21 x 14. Wood and various papers provide the ground for this delightful collage and drawing. Courtesy, Orlando Gallery, Encino, California.

4 The surface of tissue paper was collaged first, then pieces of cardboard were dipped in tempera and the drawing was "printed" on the 22 x 28 ground. Nightingale Junior High School, Los Angeles.

5 Untitled, Richard Wiegmann. Ink and collage, 18 x 24. The artist has played a fluid organic ink line against heavily brushed ink shapes. But the life comes from the number "5" reprinted many times to make a texture in the upper right, and the bold type from magazines collaged in the foreground. All the activity is in the negative space, but the figures still dominate the drawing. Courtesy of the artist.

4

2

1

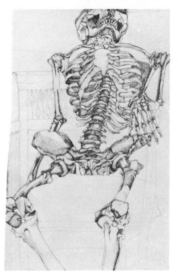

1 Apache Child, *Corinne West. Charcoal, 7 x 5. Careful observation and thousands of drawings have enabled the artist to catch the look and feel of children. Charcoal is purposely smudged in places to soften the lines and provide tone. Courtesy, White's Gallery, Montrose, California, and the artist.*

2 *Double figure studies provide problems in the relationship of sizes. This excellent contour stick and ink drawing is enriched with charcoal, which adds dimension to the 34 x 22 drawing. Hollywood High School, California.*

3 *The underlying structure of the body can be studied by drawing the human skeleton. John Marshall High School, Los Angeles.*

4 *The human figure can be drawn from a distance or from close up. This 20 x 14 nose study in charcoal provided the young artist with a lesson in awareness. Reseda High School, California.*

5 *A continually moving line describes the action of a figure. Notice how selective the student was in using line and shading in some places and eliminating it in others. California State University, Fullerton.*

3

4

5

THE HUMAN FIGURE

Throughout history, students have learned to draw by working from the human form. There are several reasons for this. One is that much of the painting that was done in their later lives portrayed people, either full length or in portraits. By learning to draw the form, these paintings would be more life-like. Secondly, in studying and drawing the human form, a student learns to look carefully and work with various media in coordinating eye and hand. The process of looking carefully is needed because each model is different and because there are such subtle changes in line, form and shading that are necessary to create a believable figure. This process of recording what you see is very important, and drawing people from observation is an exciting and useful practice.

In learning to speak a new language, complete control is not possible the first day (or month, or year). So in drawing the human form, complete control is not immediate. But if you learn to look carefully and record what you see, your ability to create a likeness of the model should improve as days, weeks or, in some cases, years go by.

It is probably best to begin with line. Making contour drawings will allow you to concentrate on the line rather than the person. The goal is not to make an exact likeness, but to learn to see and coordinate your line with your eye. Every time you draw from a student model, you should become more perceptive; your eye should become more expert at seeing. And, your hand should become more cooperative at recording what you see. If your ability to see is improved, the drawing experience is successful.

The following pages provide help in developing an ability to see and draw the human figure. Each page deals with a different approach. Select some that seem to fit you best, modify them and add to them. If you wish to look for more anatomical, proportional or structural approaches to drawing the human form, this information may be obtained from some of the books listed at the end of the book.

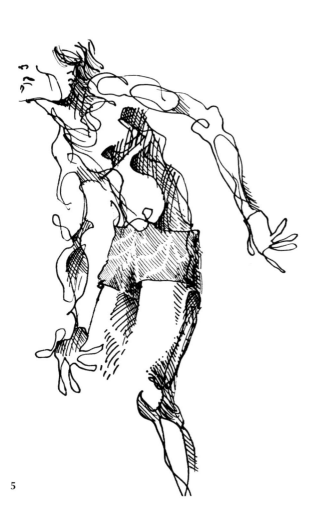

5

With most young artists, individual style and response to the model seem to improve in almost direct proportion to the size of the paper used. The larger the paper, the freer the movement and the more direct the response. The drawing tools can be held differently or the lines can be more exploratory or experimental. These freedoms tend to allow for more direct transfer from eye to hand to paper.

So see how other artists from other times have drawn the figure, look at the work of past artists. See how they have tackled similar problems and subjects, and experimented with their ideas. Compare this work with that of contemporary artists. This helps you feel a part of the history of drawing. Some artists you may wish to look up are: Paul Hogarth, Saul Steinberg, Henri de Toulouse-Lautec, Edgar Degas, Egon Schiele, Jules Feiffer, George Grosz, Burne Hogarth, Jean Dubuffet, Honore Daumier, Kathe Kollwitz, Rico Lebrun, Hokusai, Amedeo Modigliani, August Renoir, Richard Diebenkorn and others.

The Pose

Before any drawing is started, consider the model. The position and the modifying surroundings help make the model stimulating, and your interest can be kept high by a constant changing of these combinations.

The model can be on a table, platform or ladder with students below; they can be on the same level; or the model can be on the floor and the students above or on the tables. Have the model's hands holding a book or purse, playing an instrument, closed, open, reaching or writing. Have the model sit, stand, lie down, slouch, walk, recline or bend over. Have models alone, in pairs or groups. Place him in the middle of the room or at the end. Surround her with plants or chairs or still life material. Use plain chairs, stools or decorative lounges if you can get them. Use costumes (see pages 74-75) and props. Draw the entire model or only part.

Before beginning any drawing, look carefully at the new model and the surroundings for a minute or so. Absorb the lines, textures and feeling, then begin to draw.

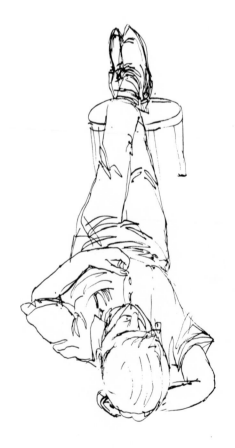

1

1 Put the model on the floor for a change of pace (or on a ladder). This quick contour line drawing is 20 x 12 in size, and done in almost continuous line with a felt-tipped pen. Wheaton High School, Wheaton, Maryland.

2 If hands of the student model are occupied, they are easier to position in the drawing. This charcoal and ink drawing was done by teacher Wes Soderberg, working along with students at Kentridge High School, Kent, Washington.

3 For variety, have two students pose together — it doubles the interest and provides problems in relative positions. Dry brush with stick and ink drawing, 33 x 24. Hollywood High School, California.

4 Try various perspectives when working from the model — keep changing and constantly challenge yourself.

3

4

2

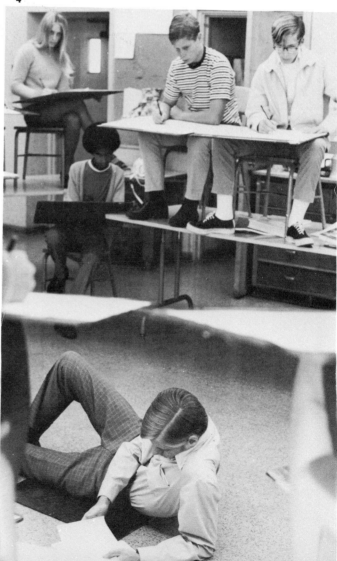

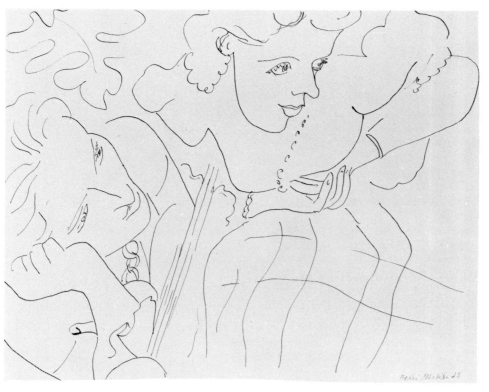

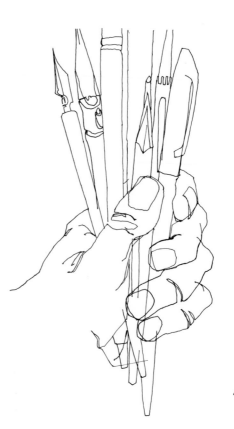

Line as Exploration / Contour Drawing

Line is a familiar element of art, since it has been used constantly in the earliest drawing attempts: the scribbles children put on everything, from walls to paper. And if the lines made are discerning and searching, they can still be among the most exciting drawing experiences.

Contour lines are non-existent in nature. They are man's convenient way of showing edges, limiting shapes, defining relief and separating colors and forms. These searching and exploring contour lines can be made slowly with emphasis on detail, or rapidly and with more concern for feeling. Attempts can be made at continuous line drawings or new beginnings as often as desired. Try several ways. Complete figures can be drawn without looking at the paper. Allow your eyes to concentrate on the model and its forms and edges. Or, if you prefer, move your eyes from the model to the paper as often as you desire. The line should follow what the eye experiences in moving over edges and contours.

Try to keep the line clean and free from repetition. Avoid a fuzzy or hairy contour line. Move the eye and hand in a coordinated action; do not draw as much with the fingers as with the hand, keeping the wrist rather stiff. This eliminates much of the distortion which often occurs. Some distortion is healthy, however, as it shows the result of discovery and really seeing a knuckle, ankle or finger for the first time.

Force yourself to make a genuine searching line, one that explores each fold and wrinkle, not a generalized line that indicates no discovery at all. Work on hands, faces and feet — separately and in combinations. Use your own hands and feet, draw them in your sketchbook. Do not go on to other figure drawing lessons until you have spent at least four or five sessions on contour drawings of various kinds.

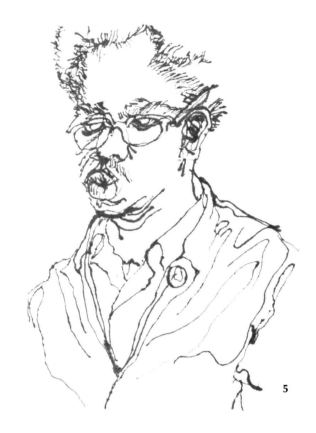

5

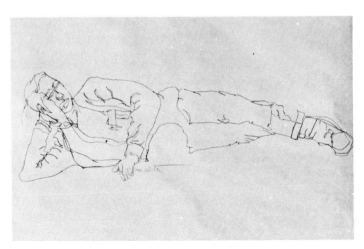

6

1 Two Heads of Women, *Henri Matisse, 1938. Pen and ink, 14½ x 19⅝. Matisse was master of the incisive line. He selected carefully the lines that were essential and disregarded the rest. Collection, The Norton Simon Museum of Art at Pasadena.*

2 *A searching pen and ink contour line has emphasized the enlarged forms nearest the artist. The model happened to be up on top of a ladder. Lutheran High School, Los Angeles.*

3 *The same model posed playing several instruments, and the ink contour lines were allowed to overlap each other. A "group" feeling is developed, with a heavy line emphasizing that feeling. Ink and pen (2 sizes), 14 x 20. Lutheran High School, Los Angeles.*

4 *Put some objects in your hand and draw a contour line that searches out forms and shapes and edges.*

5 *The lines have described only selected parts of the face and head, but they are sufficient. The paper was soft, allowing the lines to spread slightly. Fremont High School, Los Angeles.*

6 *The lines of a contour drawing should be searching and discovering folds, wrinkles and changes in the surface. This kind of searching produces a line that is characteristic of contour drawing. Lutheran High School, Los Angeles.*

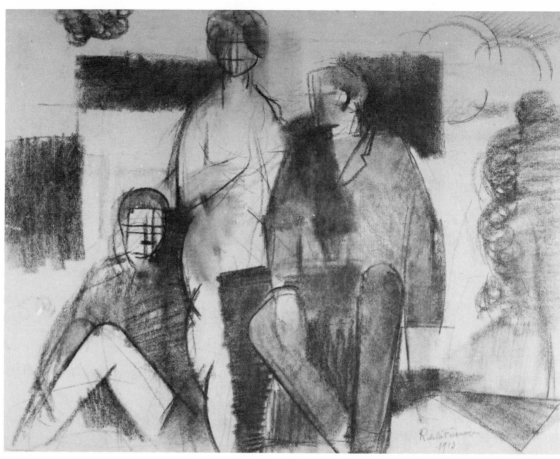

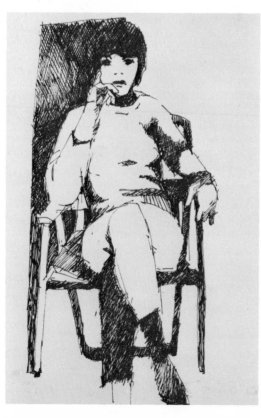

1 Le Jardin, *Roger de la Fresnaye, 1913. Charcoal, 19¾ x 25. The artist has worked light against dark and positive against negative in this cubist-style sketch. Forms are kept very simple. Collection, Los Angeles County Museum of Art, The Mr. and Mrs. William Preston Harrison Collection.*

2 *This drawing by George James shows strong value contrasts in positive and negative areas. Notice how some areas of dark background move into dark positive areas, as some light negative space moves into light positive space. Courtesy of the artist.*

3 *Black and brown crayon sketch (16 x 20) shades in the negative space to push the figure forward. Birmingham High School, Van Nuys, California.*

4 *Pencil guidelines have been erased, leaving the carefully patterned negative areas to allow the figure to appear. Pen and ink drawing from Fremont High School, Los Angeles.*

5 *Light and dark values are created with cross-hatching of a fiber-tipped pen. Notice the light against dark and dark against light manipulation of positive and negative space. Gardena High School, California.*

3

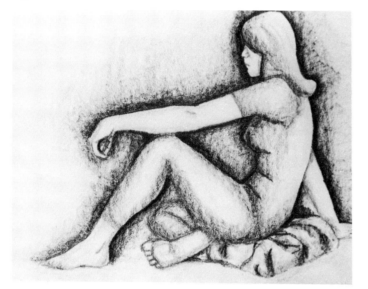

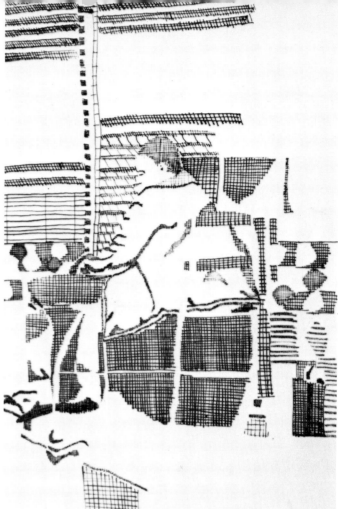

4

Positive and Negative Space

While contour drawing uses a line to emphasize the separation of the figure from the space around it, the drawings in various media on these pages use a change in value to show the same thing. The figures stand out from the background because of a contrast in values, dark and light.

You may use flat shapes, cut outs or textures, washes or lines, but the result is the same — a concern for positive and negative space rather than the contour line. The values are up to the artist. You may work dark positive areas against light negative shapes or light positive forms against dark negative space.

Drawings can be made with flat sides of charcoal (or crayon or with brushes loaded with wash), directly from the model with no sketch lines put down first. This forces a careful look at *shapes* and relationships between positive and negative spaces. Careful observation will reveal interlocking shapes, enclosed shapes, related shapes, elongated shapes, value relationships and contrasts.

In working with such simplified forms, the big shapes are important. The addition of detailed contour lines with such bold shapes can result in interesting combination drawings.

5

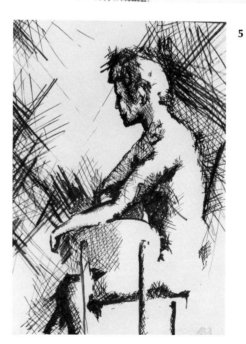

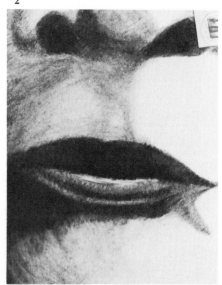

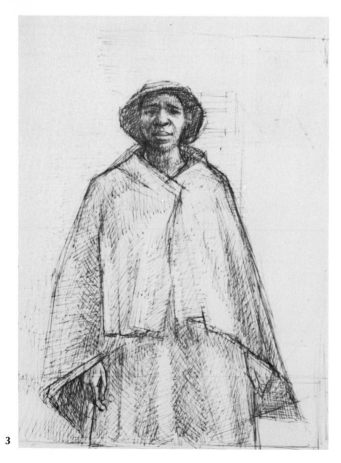

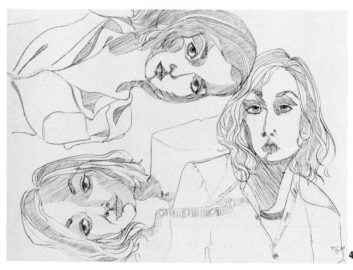

1 Sketch for Genesis, *Lorser Feitelson, 1941. Ink and Chinese white on toned paper, 11 x 20. The toned paper provides the middle value, while the ink washes turn the form and create shadows, and the white brightens the highlighted areas. Collection, Los Angeles County Museum of Art, gift of the artist.*

2 *Enlarged (24 x 18) portions of the face in charcoal, can help make you aware of the planes and projections of the head. A finder (upper right) encloses the portion of the face used from a photograph. Reseda High School, California.*

3 *Charles White used crosshatching and parallel shading lines in a pen and ink study to emphasize form. The large folds and smooth contours also helped to stress the bulk of the figure. Courtesy of the artist.*

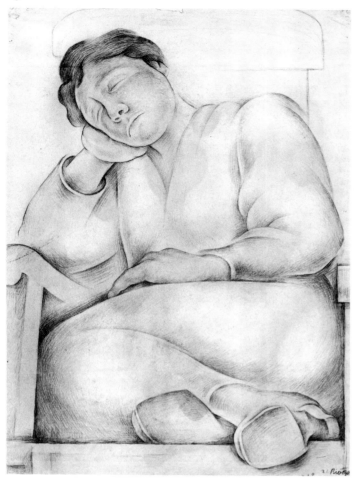

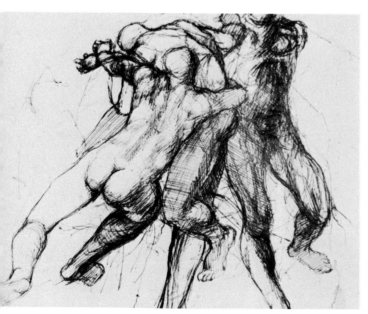

The Search for Form

Trying to place the figure in space can take many directions. This search for form continues for all of the artist's life. Ways to represent the indentations and projections, the roundness and the flatness, the forward and back — the dimensions of the human form — is a rewarding search. It begins in the classroom and never really ends. Artists use different methods at different times in their lives; the techniques you use may also change from time to time.

The search may be carried out with line — indicating the forward and back as well as the up and down, with a sensitive line. This might be the most difficult way to depict form accurately. A weighted line (thick and thin) is easier to use, as it has its own definite feeling of dimension. Lines can define contours or edges and can run over the body's rounded forms to indicate dimension.

The search might make use of the planes of the figure, advancing, receding, upright, slanting, projecting, vertical or horizontal. Recording flatness or roundness with value or shape provides some rewarding discoveries.

The search most easily takes on the use of value change. To give a feeling of roundness to the arm, a graded shadow defines the form. To draw an angular face, sharp value contrasts delineate the areas. These value changes (or shading) rely on a source of light, real or contrived, to help in recognizing the form.

Searching for such form can make use of these aspects singly or in combinations. Your individual discovery is what is truly exciting. This is the main reason that formulas are not recommended for producing dimensional effects. The discovery following each search is too personal and important. Notice how each artist in the book, not only on these two pages, indicates form. A variety of ways should be tried — as the search for an approach to form goes on.

4 *Triple self-portrait (each in a different mood) has three different shaded forms, but all use parallel lines to produce the gray. Such repeated work, in different lighting conditions, makes you aware of facial form. Hollywood High School, California.*

5 Sleeping Woman, *Diego Rivera, 1921. Crayon, 23 x 18. Rivera adds tone carefully and with reserve, but his figures always appear rounded. Collection, Fogg Art Museum, Harvard University, Cambridge. Bequest of Meta and Paul J. Sachs.*

6 *Sketchbooks are excellent places to work on a personal style in representing form. Notice that line itself, if weighted, can depict form, as in the leg at the lower left. Fremont High School, Los Angeles.*

1

2

3

4

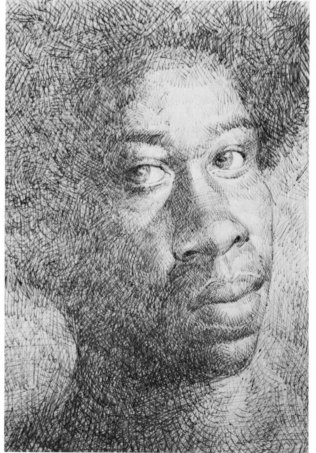

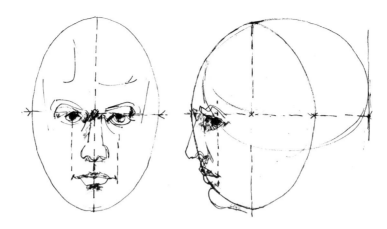

1 *If parts of the face give you trouble, enlarge (this one is 24 x 18) that section from a photograph (see upper left) or mirror. Reseda High School, California.*

2 *Early self-portraits can be simple, straightforward statements. This one in crayon (12 x 9) is from Carver Junior High School, Los Angeles.*

3 *Masks or clown faces are good places to start learning about facial proportions. Crayon and watercolor, 24 x 18. Carver Junior High School, Los Angeles.*

4 *Although a pen is considered a linear tool, Charles White used it to create soft and subtle areas of value. His facial studies are the result of very careful observation. Courtesy of the artist.*

5 *William Pajaud used line to delineate faces in a simplified way — one is extremely simplified. Try reducing your own facial features to such a few lines.*

Faces and What to Do with Them

Faces can be drawn in contour line, can be shaded, placed in dramatic light, flattened, stretched or designed. They can be drawn alone, in pairs, repeated, or fragmented and studied. They can be old, middle-aged or young. They can be drawn in crayon, charcoal, pencil or any other medium. They can be drawn from a plaster cast, a photograph, a model or friend. Regardless of the situation or medium, the drawing is based on observation. Even if drawn from memory, the face is still drawn from previously observed features. So it is necessary to look carefully at faces, noticing curves, relationship of the parts, shadows and details.

Draw the person opposite you. Draw the teacher. Have a student model pose. Draw a member of your family. Look in a mirror and sketch a self-portrait. Look carefully, see and record. Look at black and white photographs of faces and at other artists' drawings and paintings of faces. Note the ways a face can be shaded, broken into parts, posed or sketched. Look at faces in other parts of this book. Feel your own face to notice the bones and ridges, the hollows and fleshy places.

Place a hand by the face, put on a funny hat, wear a shawl or look sideways — do anything to spark interest in the pose. Make some quick sketches and produce several finished drawings. Each experience adds to your ability to see, and to your concept of *faces.*

Do not rely on formulas to draw the face or head, just observe. A few basic proportions might help get you started, but that is all. Notice what happens when heads are tilted forward or back. If parts of the face are difficult, look in mirrors and draw a part of your own face several times.

For special problems, several books might offer help. Look into Burne Hogarth's "Drawing the Human Head" or one of Bridgeman's anatomy guides. The bibliography in Chapter 12 includes a more complete list.

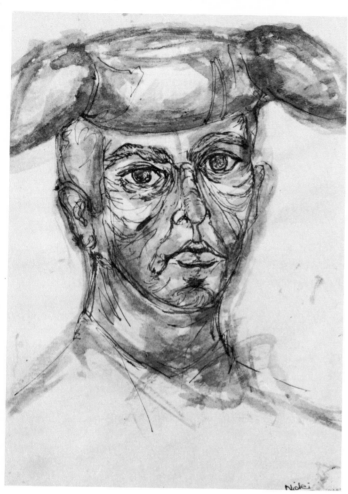

1

2

Costumes and Props

A change in wardrobe will generate new energy in your figure drawing. It is difficult to get enthused about drawing the same clothes that you see all day long in other classes. Throw a towel over the model's head, add a jacket, discard the shoes. Every change stimulates more careful looking.

If your school has "dress-up days" in connection with school events, use those days for figure drawing to take advantage of the costumes. Have several interesting clothing items around, perhaps donated or picked up in a thrift shop. Sometimes complete costumes can be rented for a week at a time. Have classmates pose in uniforms, or those from dance classes in their leotards.

Props also have a tendency to promote closer observation. Have the model hold a musical instrument, sit in an ornate chair, play a guitar, carry his shoes, sit in the still-life setup. If possible, pose the model in some sort of action and use some props. Masks placed on the model will eliminate the problem of drawing a recognizable face. The sometimes bizarre impression of a mask, together with a costume, can encouarge you to interpret the subject, along with observing and recording.

It seems to follow that the more carefully these added items are observed, the more searching are the lines that are recording the face and hands of the model. Some models generate better drawings than others, but costumes and props can make any model more interesting and stimulating to draw.

3

1 *A matador cap is a unique headpiece, and could provide some interpretative drawing. Wash, stick and ink, 21 x 16. Granada Hills High School, California.*

2 *By placing the model in the center of the room, you can observe the model from one or many directions. Charcoal drawing is from Lutheran High School, Los Angeles.*

3 *Traditional pen and ink technique (lines, dots, crosshatching) is a more finished method of working, and not spontaneous. But for some subjects it is appropriate. Lutheran High School, Los Angeles.*

4 *Fashion illustrator Ellen van Buren works with pen and ink to produce newspaper advertisements. She is accustomed to working with a variety of fashions and "costumes" in her work. Notice the interesting combination of full figure and portrait, although the hat and clothes were featured. Courtesy of the artist.*

4

1

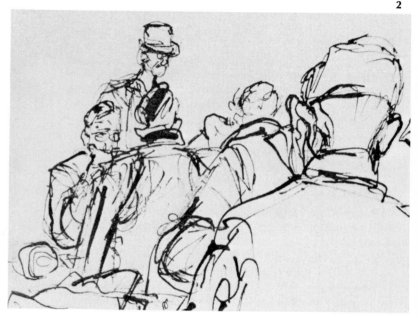

2

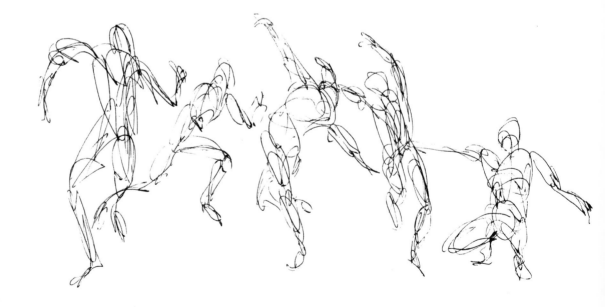

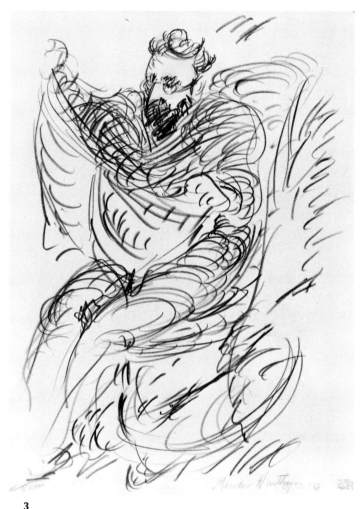

The Figure in Action

Just as costumes and props seem to generate more interest and enthusiasm in drawing class, so do dynamic action studies. Models may be posed in active positions, but the drawing will have to move rapidly because such poses are difficult to maintain. Action can better be studied in photographs and drawings made of movements not possible to pose: off balance, falling down, mass football-like action, or reaching and leaping basketball players.

Sketchy lines can imitate action to make the drawing really the active element. Edges and contours are constantly changing when the subject is moving, so clean and precise lines hardly tend to show action.

Gesture drawing — a scribbling active line that emphasizes movement — is an excellent way to develop an awareness of dynamics. Lots of one- or two-minute gesture drawings will provide excellent experiences in observing and recording motion.

Watch a dance or physical education class in practice and sketch movement. Get the big movements down first, with correspondingly large drawing movements. Then refine if you wish. But try to draw the action rather than the person.

Try some drawings that show a rapid progression of movements — the figure in various positions — all superimposed like a stop-action photograph or strobe light sequence. Have the model move through a sequence of motions (like bending over or turning around) again and again to establish a pattern, and draw the model at several places in the pattern.

A natural drawing of action can only be done through much observation and practice. Try any way that seems to suit the need at the time.

3

4

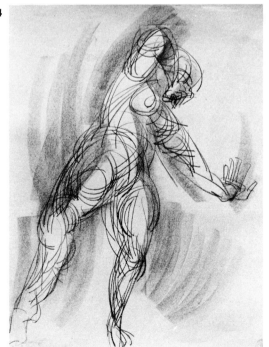

1 *This white and black tempera drawing shows the same figure in four successive poses — thus describing the figure's movement. Kentridge High School, Kent, Washington.*

2 *Ink drawing of figures in action, done on the spot and placed in a sketchbook. Fremont High School, Los Angeles.*

3 Man in a Chair, *Marsden Hartley (1877-1943). Pencil, 12 x 8⅞. Quite unlike the artist's paintings, this dynamic drawing shows action. The rocking chair is rocking and the man is moving. Collection, The Los Angeles County Museum of Art. Gift of Frank Perls.*

4 *Action drawing by Diane La Com. Conté and charcoal, 24 x 18. You can almost see the artist's hand moving rapidly over the paper to catch the feeling of movement. Courtesy of the artist.*

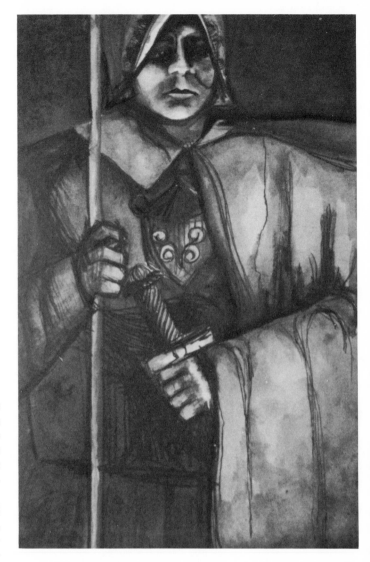

1

The Figure in Composition and Design

Where the figure is placed on the paper or what its relationship is to the rest of the drawing, is a matter of composition. In a finished drawing, all the elements of design should be considered, while in sketching they might not be so demanding. In fact, when sketching, it is often the disregard for these elements that gives the drawing its spontaneity, casualness and excitement.

When no backgrounds are used, the figures can be placed off-center, usually moving or looking into the larger open space. Or if placed alone in the center of the sheet, the various elements of emphasis should provide a sense of balance. Two figures should look as though they belong together. Groups are easier to treat, since the individual parts can be manipulated into any desired arrangement.

Single figures can be shown in their entirety or partially. They can be slanted, stretched or turned sideways. They can be self-contained or may need environmental assistance. They can be placed on the page for dramatic effect or can become part of the overall design. Often the paper can be cropped to produce a more dynamic composition.

The figure itself might become the basic shape for problems in design — pattern, texture, line, tone, movement. Try applying some of the normal still life design problems to the figure. Experiment with pop techniques or pure design elements. Work with selected parts rather than the entire figure. The greater the variety of searching that goes on, the more familiar the various aspects of the figure will become to you.

78

2

1 *The large figure seems to burst out of the frame on all sides. Student model is placed slightly off center, but light values on the right side help to balance. Wash drawing, 36 x 24. John Marshall High School, Los Angeles.*

2 *Son of Trike, Wes Soderberg. Charcoal and conté crayon. The entire figure can be centered and placed against a neutral background. Courtesy of the artist.*

3 *Self-Portrait, Valerie Love. Pencil on charcoal paper, 12 x 9. Part of the figure can be centered and vignetted against a white background. Note the feeling of rhythm, movement and emphasis. Courtesy of the artist.*

1

2

The Figure Tells the Story

Motivation for figure drawing might include illustration, or telling a story with the drawing. The figure may suggest the story or the narrative can suggest the drawing. Rembrandt worked in the former way and most illustrators today employ the latter.

Ideas for illustration can be found in poetry, short stories, television plays or in the Bible. A costume worn by the model can suggest a story and the feeling is transferred to the features of the figure. The dress, facial appearance or physical make-up of the model can recall a story or can inspire a feeling that is projected in the drawing. The pose of the model may recall a concept or action that can be illustrated.

For example, several students may be posed, sitting around a table. From the sketches made of the interacting figures, several adaptations might be drawn: Vikings plotting war movements; colonists watchfully eating dinner; men playing cards; a coaching staff diagramming strategies; students questioning a teacher and many others.

Along a similar line, the design elements and compositional techniques of master painters can be analyzed and redrawn in various styles and media. Reworking such compositions provides a fine insight into spatial arrangements as well as allowing for further experimentation with the figure.

1 *The pose and attire of the model can indicate story telling material. The teacher posed for this wash, stick and ink drawing (34 x 20). Granada Hills High School, California.*

2 *Story boards for a student film literally tell a story. This one is from Reseda High School, California.*

3 *A simple happening can be cause for a sensitive drawing. Stick and ink on oatmeal paper, 24 x 18. Lutheran High School, Los Angeles.*

4 *A sight that made a strong impression formed the basis for this 12 x 9 pen and ink drawing. Lutheran High School, Los Angeles.*

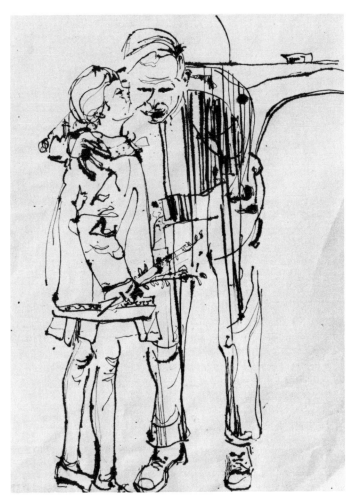

3

4

81

Experimental Figure Drawing

Some experimental figure drawing emphasizes a new style or new materials, while some depends on the figure itself. Those stressing materials could include collage, stencil or various combinations of media to produce exciting results. Changes in style might make use of the figure as a device to explore textures, pattern or design. Tracings and rubbings can become points of departure for further development. Using techniques usually associated with other drawing problems (Pop Art, still lifes, surrealism or landscape) might trigger some stimulating project ideas.

The figure itself can be analyzed in a number of ways. Put the model in an elastic sack and draw the sculptural forms. Drape the model completely in sheets and work on the folds of the material. A face, part flesh and part skull, or a hand, drawn to show bone as well as skin, may be intriguing. Faces or figures, covered with animal or flower drawings, may give you a new direction. This same idea can be carried out in collage, drawing over it with brush and ink.

Remember, there is no "best way" to draw the figure. The greater the variety of approaches, the more apt you are to find your individual style of working.

It is impossible to exhaust the possibilities. Select one or several, adapt and add, and alway be awake to new or better ideas — especially those you may discover yourself.

1

1 *A tagboard stencil was made of a figure shape, then traced in numerous positions. Positive and negative areas both were spattered, crayoned or patterned with oil pastels on 18 x 24 dark construction paper. Paul Revere Junior High School, Los Angeles.*

2 *This ink drawing is from a Benjamin Franklin bust, with all areas carefully filled in with animal shapes. Concordia Teachers College, Seward, Nebraska.*

3 *Use of pen and ink creates a decorative composition. Some white tempera was used in negative areas of the 18 x 24 drawing. Gardena High School, California.*

4 *Self-Portrait, Tom Sylwester. Pencil, cutout and mounted on dark paper, 16 x 14. Portrait shows both surface and bone structure of the face. Courtesy of the artist.*

5 *Attempts at caricature are excellent ways to discover aspects of the figure. Ink and colored markers. Fremont High School, Los Angeles.*

6 *George James looked at these people from above (and past a hanging light fixture) which changes the appearances of the figures completely. Courtesy of the artist.*

2

82

3

5

4

6

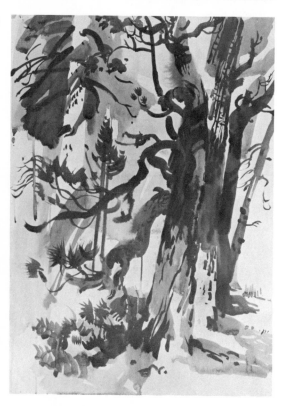

1 Both close up and distant landscape elements are used in this soft and warm drawing. Done in pencil and brown and orange colored chalk, 22 x 16. Wheaton High School, Wheaton, Maryland.

2 Tree Rhythms, *Robert E. Wood.* Brush drawing, 18 x 24. Watercolor washes express the growth and struggle of growing trees in a limited environment. Selectivity of the elements is essential to good design. Courtesy of the artist.

3 Middlesex, England, *Gerald F. Brommer.* Fiber-tipped pen in sketchbook, 8½ x 11. Selecting some elements of the landscape and rejecting others is a matter of much practice and hours of drawing.

4 Living plants are part of a growing environment and make excellent subjects. Pencil, 24 x 18. Concordia Teachers College, Seward, Nebraska.

6

THE LANDSCAPE AND
ITS ELEMENTS

4

Landscape drawing is alive and well. In our current preoccupation with ecology and the quality of our environment, the landscape and its various parts have again become vital. Urban students certainly do not come in personal contact with landscape as intimately or as often as suburbanites or students living in rural areas. But they are still concerned and should easily be motivated to search out the multitude of aspects that landscape presents.

Most major painters have been interested in landscapes and have drawn or painted them in their individual styles. Some artists like the refreshing quiet that a landscape represents; others enjoy the fury that nature can whip up for the viewer. Some see landscape in huge chunks or panoramas while others enjoy the intimate details presented by a bit of bark, some leaves or an eroded surface.

Careful searching is rewarded with personal insights, since everyone sees nature differently. Learn to select items from the total picture, rearrange the parts to re-create a new whole, analyze growth patterns, mass lights and darks to create pattern. Sometimes work quickly, searching for large shapes and characteristic patterns; or work slowly and deliberately, defining individual characteristics of special trees, rocks or plants. It is in such diverse searching that the essence of the landscape can be found. Explore on foot and with pencil; search with eyes and with wash; discover with fingers and with charcoal.

Fill sketchbook pages with observations and notes, both visual and verbal. Explore "shorthand" techniques (squiggles or doodles that imitate the textures of nature) for making pine trees, or granite rocks, or ocean waves. Draw from nature or from slides (a poor substitute, but necessary if you live twenty miles from the nearest open space). Hold part of a landscape in your hand and draw it — or sit right next to a tree to draw it, but always be aware of the textures and lines that give each plant or tree or mountain its character. And finally, look to see what Vincent Van Gogh, Paul Cezanne, Georges Rouault, Paul Hogarth, William Turner, John Constable, Norman Kent, Rembrandt, Claude Monet, or Winslow Homer saw in their landscapes. Each felt and drew his environment differently; each loved his surroundings; and each brought his own style of work to the landscape he drew.

From Close Up and Far Away

If you go out into a landscape to sketch you have to feel it, and that helps determine what you draw. You must be selective. You can't possibly put down everything you see — so pick out something that interests you and begin with it; then draw other things in relation to it. Select from the many things available and arrange them to suit your composition. Make studies of individual plants, rocks, clouds, trees, flowers or earth. Try several media to see which work best in the outdoors.

If you cannot get outdoors, bring the environment into the art room. Drag logs, branches, leaves, flowers, or rocks into the room. If a storm breaks branches, take advantage of this. Sketch from slides or photographs and work as in nature. Select and rearrange the parts to suit the purpose of the drawing.

Explore aerial and linear perspective as they relate to space in the landscape. Work close up to some objects or capture the panoramic feeling of a whole countryside. It depends somewhat on where you live. Just what do you feel about the landscape? Its moods at different times of the day? Its appearance during different seasons of the year? Its varying textures and surfaces? Do not relegate your landscape drawing to pictures of places, but become involved with its smells, its temperature and its color — and then draw it . . . let *it* effect *you*.

You can convey feelings of grandeur or moods of loneliness. You can make it appealing or mysterious. You can show growth or death, design or clutter, man's presence or absence, masses or details. It depends on how you react to the environment, that day.

1

1 *A felt marker was used to search out the close-up forms of a bamboo clump. Look for patterns and shapes in the landscape that allow for interesting treatment and compositions.*

2 *Four "three value studies" by Robert E. Wood, each 7 x 9 inches. The artist has used three washes of different values to block in the shapes and tones. Such sketchbook studies help the artist to select gray values to match colors in nature. Courtesy of the artist.*

3 *A decorative pen and ink drawing (18 x 12) uses stylized leaf shapes in a close pattern to simulate trees, ivy and shrubs. Areas left unfilled are important to the drawing. John Marshall High School, Los Angeles.*

4 *On-the-spot sketchbook study by the author makes use of "shorthand" doodling to generalize each kind of plant and rock in the area. Fiber-tipped pen, 8½ x 11.*

5 *An imagined landscape close-up, jammed full of plants and insects. Pen and ink, 12 x 18. Nightingale Junior High School, Los Angeles.*

2

3

4

5

1

2

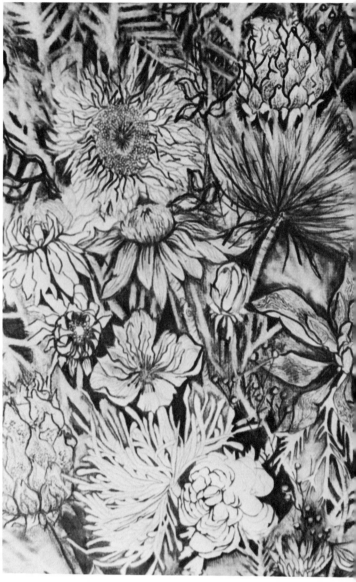

3

88

Flowers, Leaves and Wood

Landscape drawing usually consists of arranging the various elements in the environment to produce a satisfying composition, but the elements themselves are worthy of individual attention. Logs, driftwood, leaves, branches, flowers or seeds make superb subject matter for any and all media. They can be drawn individually or in groups. They can be conveniently explored and experimented with in the art room. They can be held, felt, smelled, bent, turned over and around, and drawn as sketches or detailed renderings. Enjoy their life and organic structure and explore their forms and surfaces. A thorough search of contours or textures should instill in you a visual awareness for the rest of your life.

H.L. DAHL

4

1 *Traditional pen and ink techniques (parallel lines and cross hatching) are used in this 8 x 10 plant drawing by the author. Note the development of values built up with a single-sized fine point.*

2 *Go out of the classroom and see what criss-crossing branches look like. Pencil drawing, 18 x 14. Reseda High School, California.*

3 *Hold individual flowers in your hand and draw them (these are artificial) to form a cluster or complete bouquet. Detail of a 24 x 18 pencil drawing. Birmingham High School, Van Nuys, California.*

4 *Light and airy feeling of the grass is evident in this sketch. The 24 x 10 drawing is in pen and ink — the butterfly is collaged. Subject was derived from a Japanese Haiku. Lutheran High School, Los Angeles.*

Experimental Approaches

Experimentation in landscape drawing may take several directions; working with the media or with the subject matter.

Try mixing media to produce exciting textures or surfaces in the landscapes. Collage rice paper on illustration board for fantastic surfaces for wash drawings. Try drawing on wet paper or experiment with resists of various types. Visual awareness is boosted by spending time exploring one subject (a cluster of seed pods for example) in several media. Produce imaginary landscapes (from another planet) in exotic media combinations that can be surrealistic in feeling.

Subject matter can be pushed and explored in all directions. Draw small items (a peach pit) in mammoth blowup, detailing all their textures and lines. Condense a huge landscape panorama into a capsule pen and ink drawing. Try to draw the *movement* of trees or grass or growth. Discover the textures on a branch or tree trunk and make designs from them. Abstract the essence of flowers or leaves and produce patterns and designs from them. Explore the surfaces of seeds or pods and develop designs based on them. Take natural forms such as trees or branches and outline them, filling in the spaces with noodled patterns.

Any experimental approaches to an entire landscape or its elements is worthwhile, because from them, a more acute awareness of nature inevitably develops. In exploring nature's arrangements and your own rearrangements, you become increasingly familiar with the forms and features of your natural environment.

3

1

2

1 Mushroom, Greg Pickrel. Pen and ink, 10 x 12. Take an organic object and use a directional (vertical or horizontal) line technique. Courtesy of the artist.

2 Mushroom, Greg Pickrel. Tempera resist and ink, 10 x 12. Cover areas to be white with white tempera, gray areas with dry-brushed white tempera. Cover the entire shape with India ink, and when dry, wash under faucet. Tempera areas will dissolve away, leaving the interesting textures you see here. Courtesy of the artist.

3 The mechanical line of a wide pen does not seem to be the proper tool for drawing organic landscape features, but Sam Clayberger turned such an unlikely technique into a fascinating drawing. Courtesy of the artist.

4 Condense a real or imagined landscape into a small area. Pen and ink, 14 x 12. Lutheran High School, Los Angeles.

4

1

2

3

1 *A complex flower arrangement is given directional pen and ink treatment. This necessitates simplification in the 24 x 18 drawing. John Marshall High School, Los Angeles.*

2 *Sections of complex still lifes become more simple if a tagboard frame helps restrict the subject. This is a helpful device with beginning drawing students.*

3 *Still lifes can be placed in several parts of the room and left there for study and work. Arrange the parts carefully to be viewed from many angles.*

4 *Ordinary kitchen sink (and environs) can become exciting when patterns are introduced. White spaces form relief from extra-busy designs. Pen and ink, 24 x 18. Gardena High School, California.*

THE STILL LIFE

To most drawing students, current and former, the word *still life* conjures up a grotesque arrangement of things — some complicated and some simple — but always *arranged* by a diabolical instructor. And surely the need for working from the still life setup remains valid, although the handling might be different. Most art rooms today have several still lifes in them, and they get changed often. They are up constantly, even when not being used by the entire class, and many get arranged by diabolical (or creative) students.

Working from a still life may involve only one or two items, or could involve dozens of things. It can incorporate living plants, manufactured auto parts, cut flowers, paper sculpture, manikins, dolls, a real live person, a plaster bust, bits of cloth, jars, bottles, pottery, musical instruments, chairs, books, shoes and stuffed animals (to name only a few things).

Drawings of objects can be done in line, value, color, texture; in perspective or flat; patterned or realistically; in one media, or mixed media; selectively, completely, directionally or partially. But every differing approach still involves looking, seeing and recording.

The still life is valuable in the drawing room for several reasons:

It can be studied for any length of time desired.
The light and shadow can be planned and controlled.
Color and texture can be arranged at will.
Certain important elements can be emphasized.
A variety of approaches can be tried on the same subject.

Attempts should be made to keep the subject stimulating. This can be done by introducing new elements occasionally, by changing your position or by adding organic subject matter (plants, animals, bones, etc.). Try drawing the entire still life . . . only part of the set-up, or a small fraction of the total. Isolate objects and draw them separately or draw them in relationship to other objects. But keep drawing.

4

1

1 *Careful and selective contour drawing eliminates generalization and stresses perception. Four objects were drawn, with six minutes spent on each. Pencil, 24 x 18. Lutheran High School, Los Angeles.*

2 *Start in the center of a mammoth still life and work out to the edge of the paper. When a contour crosses another object, take off on that one — in the direction of the edge. Go back to the center and start again. Felt marker on oatmeal paper, 24 x 18. Lutheran High School, Los Angeles.*

3 *"Take off your shoes and put them on the table." This can provide subject matter for contour drawing. Pencil, 24 x 18. Lutheran High School, Los Angeles.*

4 *Making contour drawings of objects with heavy ink lines will help you to learn to see.*

Exploring with Line

Whatever the still life subject matter, it may be searched and explored in several ways, the most convenient being line. Although line is much used, it still is a valuable tool in delineating what is observed.

Begin with single items on a table: shoes, jars, bowls or boxes. Draw them in contour, separately or overlapping, making up arrangements as you go along. Draw them in pencil or newsprint or with pen and ink or fiber-tipped pen on bond paper. Make the items large. Watch the shapes and contours that characterize each item — remember, you are learning to see. Draw the complete object or be selective about the parts you outline, but always look carefully and become more aware of what you see.

Select only a few objects from a large set-up and outline them, deleting other objects at will. Pick out only the mechanical objects, the organic objects, or the cool-colored objects and omit the others.

Change drawing material from time to time (pencil, fiber-tip, pen and ink, stick and ink) as well as paper (bond, drawing, oatmeal). Keep the media challenging and exciting — even changing in the middle of a lesson.

Change your approach to the contour line and the still life. The growth in ability to see will continue as long as the search uncovers something stimulating.

2

3

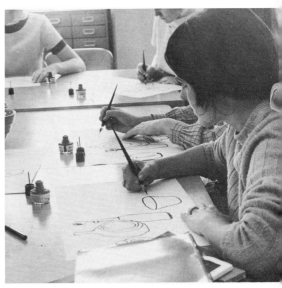

4

Exploring with Values

After exploring the forms and directions of still life subjects with line, try working with value. Any number of methods can involve light, shadow, value, contrast, positive and negative shapes, and often the familiar line is a welcomed addition. Charcoal and pencil are excellent dry media for such drawing, while ink washes, combined with line, are superb for searching and discovering values with wet media. Combine approaches and media. Experiment with paper. Move around the still life. Try one on the floor in the middle of the room, or have one go from floor to ceiling.

If drapery used in a still life changes shape too often, dip it in thick starch or white glue and allow it to hang to the required shape. When dry, it will remain static.

1 *Negative space receives the charcoal for a change. Size is 12 x 18.*

2 *If you tend to generalize too much on drapery shadows, cut or tear the shadow shaped and collage the drapery. Cut black paper, 15 inches high.*

3 *Each change in value is outlined and the appropriate value is shaded in. Awareness of value changes and contrasts is the goal of this lesson. Pencil, 24 x 18. Concordia Teachers College, River Forest, Illinois.*

4 *The center of the drawing is toned to appear dimensional, but continuing contour lines and flatly shaded dark value areas complete the search of this still life. Pencil, 24 x 18.*

4

The Way It Really Looks

There may be times when you will want to make realistic representations. Carefully rendered drawings are time consuming and demanding, but the "seeing" process is often put to the ultimate test in such problems. Care should be taken that these challenges are not meaningless or merely repetitious. After a certain period of time the growth that might take place is negligible compared to what might happen in another drawing situation. As long as a challenge is present, keep the work going.

Analyze shapes, proportions, shadows, reflections, reflected light, transparency, softness, firmness, hard surfaces, glass, paper, wood and the many small but important differences that characterize each material and object. Start simply, with one or a few objects, and see what develops. Place a single spotlight, if possible, to cast direct and permanent shadows; and when several days are required to finish the work, take care that shadows are controlled. Beware of the possibility of overworking these drawings and having them become tired. The dry media (charcoal, pencil and conté crayon) work best in such detailed drawing, but do not exclude pen and ink completely in your thinking.

1

2

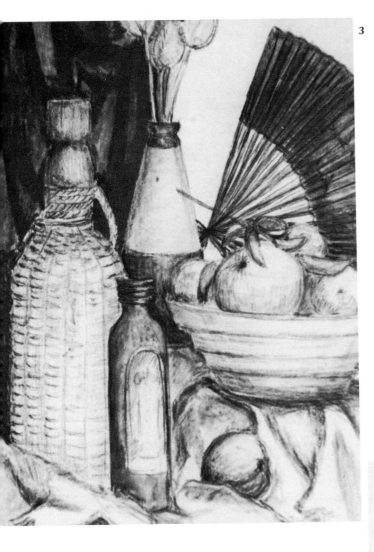

3

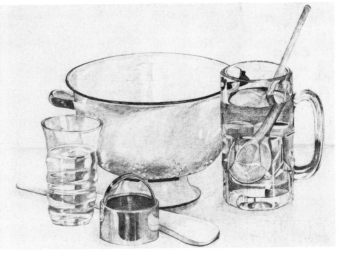

4

5

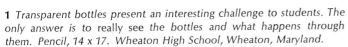

1 *Transparent bottles present an interesting challenge to students. The only answer is to really see the bottles and what happens through them. Pencil, 14 x 17. Wheaton High School, Wheaton, Maryland.*

2 *Several values of soft gray chalk are used to show the value contrast in the still life objects (12 x 18). Lutheran High School, Los Angeles.*

3 *Careful observation is needed to detail such a still life. This one seems about to burst out of the frame. Charcoal, 24 x 18. Gardena High School, California.*

4 *A hard-finished mechanical metal part is done successfully in ink and wash, 12 inches high. Watch for reflected objects as well as light. Nimitz Junior High School, Los Angeles.*

5 *Careful observation and equally careful shading can produce accurate reflections, forms, shadows and refractions. Such pencil renderings can consume many hours of looking and working. California State University, Fullerton.*

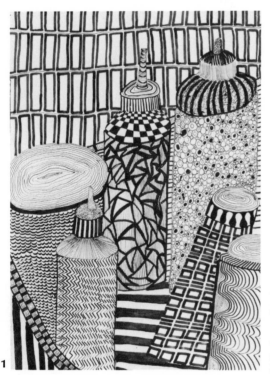

1

Design and Pattern

While some young artists can spend long periods of time looking for subtle value changes in a shadow, and recording them carefully with pencil on drawing paper, others can spend hours "noodling" patterns on a completely different type of drawing.

Parts of a still life subject can be drawn in contour, and when the design is completed, the areas may be filled in with patterns. These pattern ideas can be worked out in sketchbooks and kept ready to pour onto finished drawings.

1 *Several sizes of pens are used to pattern some ordinary tubes and jars in the art room. Pen and ink, 24 x 18. Gardena High School, California.*

2 *Negative space is highly patterned, while positive shapes show only the outlines of labels and words. Pen and ink, 18 x 24. Reseda High School, California.*

3 *Art room work bench is partially patterned, partially untouched. Ink and wash, 24 x 18. Gardena High School, California.*

4 *Flowers can be simplified and stylized to form a pattern. Work becomes flat when placed against a black background. Pen and ink, 23 x 17. Birmingham High School, Van Nuys, California.*

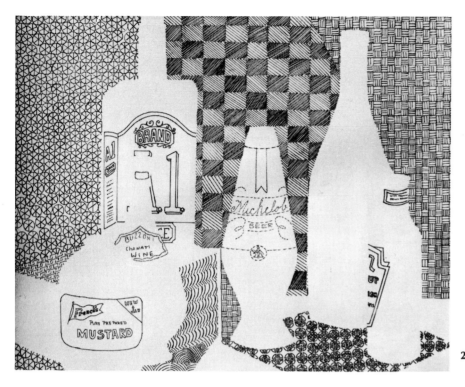

2

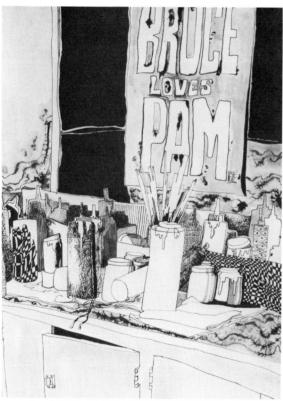

3

4

1

Mechanical Objects

Isolated manufactured forms or groups of such objects can make fascinating still life subject matter. Parts of cars, tools, bicycles, typewriters and a host of assembly-line products can be a real challenge. Depending on the media used, the objects can be rendered realistically, made into organic monsters, augmented with patterns, or handled to exploit their forms and shapes. An automobile engine or complete motorcycle would make a fascinating permanent model in the art room.

2

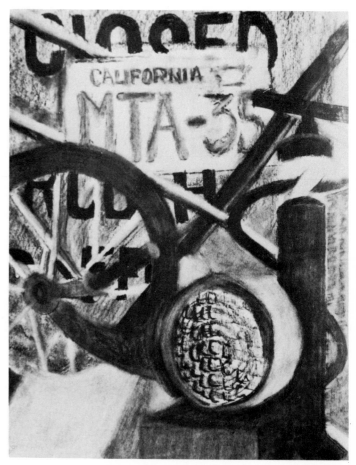

3

Experimental Approaches

Most of the experimental work done with the still life involves what is done to the subject. It can be crumpled, collaged, fragmented or rearranged by the artist. The media can be combined with novel applications or new ways to see the objects. If still life time begins to drag, try a few of these ideas.

1 *Line (and values created by line) are used to describe a still life made of mechanical parts. Stick and pen and ink, 24 x 18. Gardena High School, California.*

2 *Part of a typewriter is drawn in contour and then darkened in places to produce a strong design effect. Pen and brush and ink, 18 x 24. Lutheran High School, Los Angeles.*

3 *A realistic interpretation of part of a much larger still life made from mechanical or manufactured parts. Charcoal, 24 x 18. Gardena High School, California.*

4 *Take parts of a still life and break them up, fitting them into pre-drawn shapes. This one added a portrait. Pencil, 18 x 18. Lutheran High School, Los Angeles.*

5 *A lawnmower is stylized and drawn, with extra wheels and some patterns filling out the drawing. Pen and brush and ink, 18 x 24. Paul Revere Junior High School, Los Angeles.*

6 *Use dots (as in pointillism) to show an object's tonal values. Stick and ink, 24 x 15. Gardena High School, California.*

5

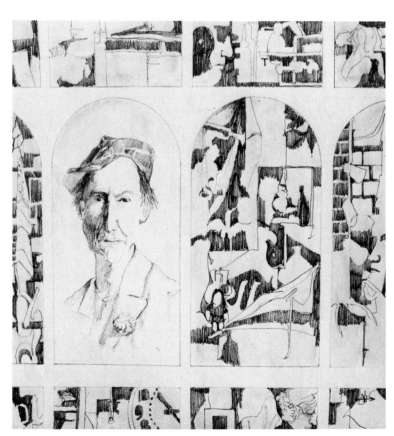

4

6

103

1

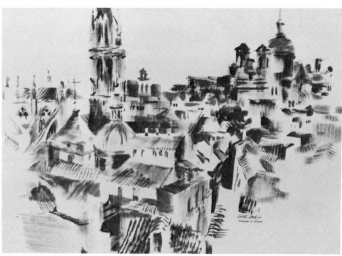

2

1 Rooftops of Toledo, Spain, *Robert E. Wood. Sepia drybrush drawing, 22 x 30. No pencil guidelines were used, but the artist, because of his experience, is able to select and place his objects directly with the brush. Absolutely perfect perspective is not needed in this type of drawing. Courtesy of the artist.*

2 *Initial drawing is in stick and ink, from a sketchbook drawing (and a photograph for detail). A few watercolor washes helped create values, and therefore depth. Linear perspective is vital to a correct feeling of the place. Stick and ink and watercolor washes, 30 x 22, by the author.*

3 *Parts of buildings help identify a city, and sketchbooks are good places to record these findings. This is part of the roof of the train station in Lucerne, Switzerland. Fiber-tipped pen in 11 x 8½ sketchbook, by the author.*

8

THE URBAN ENVIRONMENT — ARCHITECTURE AND PERSPECTIVE

3

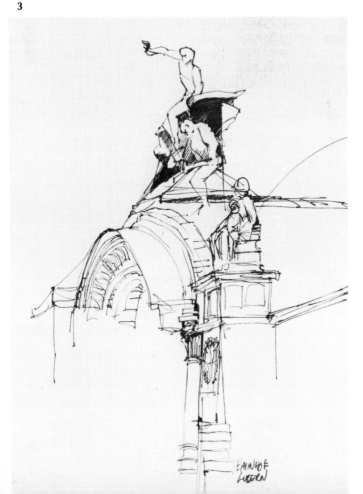

Drawing buildings and the city environment can be a lifetime job because of the variety of structures, building styles in various parts of the world and the compositional possibilities in grouping structures together. Probably the greatest asset is a selective eye, one that can eliminate unwanted material and concentrate on the aspects that will produce the most exciting results.

Though most drawings of cityscapes or houses seem extremely detailed, it is the basic structure of the composition that determines its success as a drawing. When confronted by a group of buildings, it might be helpful to follow this plan: (1) half close your eyes to help eliminate detail and concentrate on shapes or values; (2) outline those major shapes — they are the main construction lines and are the first lines to draw; (3) then fill in *selected* detail, the items that characterize the building (its feeling and history included — not just how it looks). Sometimes a finder (small open mat) held at arm's length, helps limit the area of concentration.

A close-up study of bricks, boards, window details, roofs, chimney pots, steps, doorways and railings often is valuable in placing later detail in a drawing. And if drawing is a search, then these close-up studies are valuable in themselves, just as in landscape drawing.

The physical aspects of depth can be indicated by placement of shadows and light — variations in value. Textures can be indicated in appropriate shorthand or by detailed rendering. Generalize some aspects of the drawing and concentrate on details in other areas, because this technique keeps the drawing fresh and interesting. Almost all the examples shown in this chapter bear this out.

Individual styles of working are again desirable, and these grow only out of constant working. Copying other drawings only prolongs the emergence of style and dulls the value and spontaneity of the product. But it is valuable to check out the drawing styles of Paul Hogarth, Richard Downer, Norman Rockwell, Ernest Watson, Mario Cooper, Ralph Hulett and others, just to see how they handle various problems. Try drawing your own house, take a field trip to interesting areas of town, or sketch from slides or photographs.

And finally (or initially) you must know something about perspective.

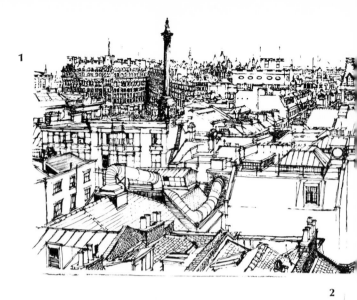

1

Perspective—Drawing in Three Dimensions

Perspective is drawing objects the way they appear to the eye. We know from observation that things look smaller in the distance; drawing them that way gives the illusion of depth of space. A feeling of depth is also achieved by overlapping shapes: A tree in front of a house visually indicates a space between the two. It *looks* right. Aerial perspective involves making distant objects fuzzy and less distinct, and often lighter in value.

Buildings cause special perspective problems when seen from an angle. Lines on a building (roof, window or foundation lines) that run away from the viewer *all* begin to converge toward the horizon or eye level. The eye level is an imaginary line across the picture at the level of the observer's eye — when looking straight ahead. All horizontal lines in the building that are above the eye level will slope *downwards* to a vanishing point (where lines converge) and all lines below the eye level will slope *upwards* to meet at the vanishing point. When looking at a building head on, or when looking down a street, only one vanishing point is needed. When looking at a building from an angle, two vanishing points are required. See the sketches for examples. Drawing buildings on hills are much more difficult, but the solution can be figured out in the same way. (Many pages would be required to show and explain all perspective problems and solutions.)

Several perspective problems should be tried early to familiarize yourself with the functions and uses of perspective. It should not be a slave driver after that exposure, but a good friend that can be called on later, whether you are working with architecture, the figure, landscape, or still life.

2

3

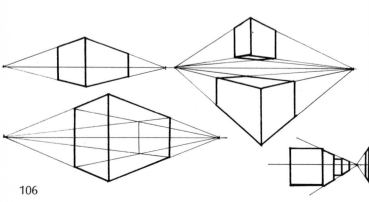

106

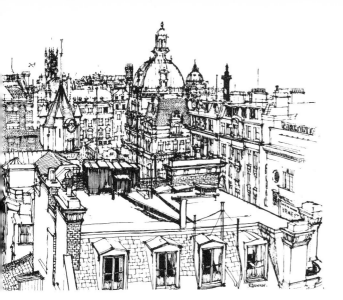

5

4

6

1 London Rooftops, Richard Downer. Fountain pen and black ink, 9 x 26. A very complex on-the-spot drawing. Vanishing point for most buildings is in the center of the drawing. Notice how some areas are left blank to give the eyes a rest. This is part of the artist's selective process in such a complicated urban scene. From the artist's book Drawing Buildings, courtesy of Studio Vista Limited, London.

2 Shade one object but keep the rest of the area in linear perspective — two vanishing points. Pencil, 12 x 18. Reseda High School, California.

3 Two point perspective study of an imaginary set-up, adding shadow to strengthen the dimensional feeling. Pencil, 18 x 24. Lutheran High School, Los Angeles.

4 A freely drawn sketch by George James involved the use of several washes and line. A knowledge of perspective is evident in the receding lines, but absolute accuracy is not called for in this sketch. Courtesy of the artist.

5 An imaginary maze, done in pencil, uses both linear perspective and shading to enhance the dimensional feeling. All horizontal lines lead to one of the two vanishing points, while all vertical lines are perpendicular to the base of the page. Concordia Teachers College, Seward, Nebraska.

6 Combination of shaded flag (or anything else would do) and linear perspective of the art room wall. Pencil, 18 x 12. Reseda High School, California.

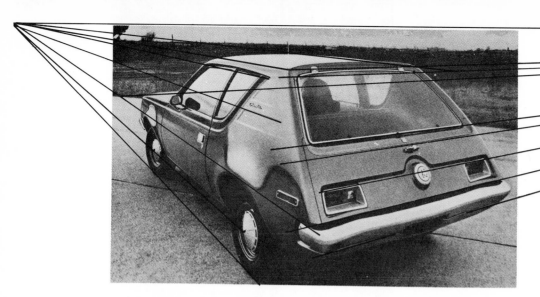

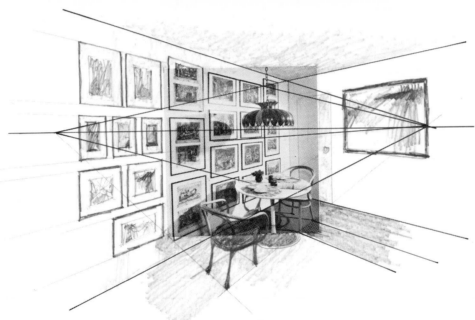

Photographs can be drawn over, illustrating the principal of two-point perspective . . . but look out for distortion of wide angle lenses used by the cameraman. Lines can be drawn on photos of cars to vanishing points so that automotive perspective can be studied. Photos can help a great deal in teaching perspective.

Using the lines in the photo, find the vanishing point (at left) and continue the lines of the room or house, exploding the photo with pencil and extending the textures and furniture from the photo outward. Two point perspective in a room (same as inside a box) can be drawn over many photos, and also extended to clinch perspective concepts.

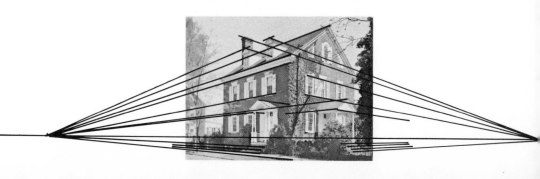

Putting Perspective to Work

A careful study of photographs that include buildings is an excellent means of clinching perspective principles. Lines drawn over magazine illustrations will strengthen newly-learned ideas and discoveries. A feeling of depth in a drawing can be emphasized by varying the weight of the lines. Objects nearer the viewer can be drawn with heavier lines than distant trees and buildings. Washes or pencil shading should be darker up close, lighter farther away. This generally will give a greater feeling of solidity to the structures and is known as *aerial perspective*.

In drawing cities and structures, the feeling of depth is enhanced by framing the foreground with close-ups of edges of buildings, windows or trees, and, perhaps, keeping it simple. This forces the eye to move into the middle ground where the main subject is most often found. By using this device and the darker foreground together with linear perspective (lines converging at a vanishing point), a strong sense of depth is developed.

The overlapping of buildings also pushes others back into the picture, and shading from a single light source strengthens the solid feeling. To emphasize bright sunlight, put detail in the shaded sides of buildings and leave the sunlit sides void of detail. This produces a feeling of glare as if the brightness of the sun had eliminated detail. Each of these devices produces a sense of perspective: all of them together can be extremely dramatic.

Try to notice how these ideas really work when you drive or walk through town. You do not have to sketch a building, just look and see that the principles of perspective drawing are always sound.

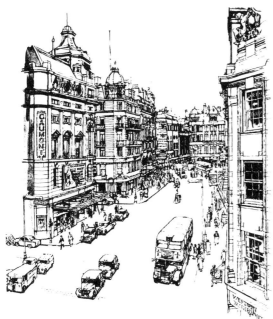

3

1 Haymarket, London, *Richard Downer. Pen, India ink and wash, 18 x 15. Linear perspective causes buildings, automobiles and people to get smaller as they get farther away. The large white area (the street itself) is a restful area in a complex subject. From the artist's book,* Drawing Buildings, *courtesy of Studio Vista Limited, London.*

2 *Studies showing ways to achieve a feeling of depth and space. Line, shadows and overlapping shapes each can do it alone, but in combination the feeling is quite strong. Pen and wash, 18 x 24, by Robert E. Wood.*

3 Puerto Vallarta Street, *Ralph Hulett. Charcoal, 18 x 24. Vertical lines lean and perspective is distorted to create a feeling of dilapidation. Angle of the uphill stairs presents another perspective problem. Courtesy of the artist.*

1 One point perspective, down a street in Jerusalem, shows arches getting smaller as they go away from the viewer. Fiber-tipped pen in 11 x 8½ inch sketchbook, by the author.

2 Stylization of buildings, taken from a photograph, emphasizes the patterns and shapes of the structures. Pen and ink, 18 x 12. Lutheran High School, Los Angeles.

3 Draw your own house, or some house in the neighborhood, and practice the rules of perspective. Lines go in the direction of the vanishing points but are not exact. Stick and ink, 24 x 18. Lutheran High School, Los Angeles.

4 A fire or storm can furnish excitement and drama to a cityscape. Charcoal, 24 x 18. Lutheran High School, Los Angeles.

5 George James' sketch (fiber-tipped pen) shows a complete knowledge of perspective, but not a strict adherence to the rules. Once you understand the principles, you may use them in a general way in sketching, but need not draw lines to vanishing points. Courtesy of the artist.

Interpreting the Urban Scene

Buildings exist in the city, but so do people. The buildings are there because of the people; and while some artists are fascinated by the structures and their history, other artists' hands are set in motion by the presence of people. In interpreting the city or town, it is necessary to feel the presence or lack of people. Human figures can be placed in the drawing to show scale or size by comparison, or they may become central to the feeling of the drawing. You may show the result of human presence or the loneliness due to the lack of people. Some cities or towns have certain forms of architecture, decoration, street lights, parks, statues or mailboxes that are characteristic to that locality alone. Spend special time on these features.

Cities can be shown in daylight or at night, from a distance or close up, in individual parts or massed together. How you draw each part or the total city depends on how you feel about the parts or the whole. Then it is your interpretation and your style — and your drawing.

1

Experimental Approaches to City Drawing

Experimental architectural drawing is often difficult to find, although some techniques are fascinating. Media can be explored experimentally while the artist is using urban subject matter. Collage and drawing can be combined effectively and crayon etchings and resists provide colorful and exciting results.

Experimentation in the working techniques themselves might provide stimulating drawings. Draw on unconventional backgrounds or handle different aspects of the city with different media. Make the buildings organic rather than static blocks. Combine indoors and outdoors in a single drawing or bring the country into the city.

Exploratory handling of subject matter can provide startling and often satisfactory drawings. Distort perspective or even try reversing it. Break up the parts of a city and either leave it fragmented or put it together in a bizarre fashion. Emphasize the distant parts of a city drawing rather than the foreground. Try to apply some cubist, pop, or art deco techniques to city drawing. Flatten out a city, with no perspective at all, just pattern and shape. Simplify a city street into black and white shapes with no middle values. Each experiment should help one see the city better and with more perceptive eyes. As awareness is one of the goals in drawing, any problem that stimulates seeing in a new way is valuable.

2

1 *Parts of the city are drawn, others cut out of magazines and collaged on a 22 x 28 sheet of tagboard. Ink lines and washes are used to combine all the elements into a unit. Hollywood High School, California.*

2 *Purposely distort the perspective to create a "nightmare feeling." Ink, wash and collage, 24 x 18. Reseda High School, California.*

1 Plexus, *Kerry Strand and a CalComp computer, 25¼ x 31.* Computer plotters can be programmed creatively to produce some excellent results. Courtesy of California Computer Products, Anaheim.

2 *Using a machine that he designed and built, artist Paul Allen makes use of the fields of gravity to produce very interesting drawings. Ink and machine, 8 inches long. Courtesy of the artist.*

3 *Subject matter and handling of materials provides a pop look to this portrait. Rubber cement resist, with ink and watercolor washes, 22 x 16. Nightingale Junior High School, Los Angeles.*

4 *An op art drawing using fiber-tipped pens. Lutheran High School, Los Angeles.*

9

OP, POP AND OTHER THINGS

Some drawing problems can reach right into the realms of science or the concepts of pop art painting. Others can take advantage of the physical properties of certain materials to produce unique effects. But whatever the process or its initiating force might be, some exciting and fascinating results are evident. Some might fall into categories of experimentation; others rely on pure measurement; and still others perhaps are the basis for further exploration in other media.

No medium seems "best" for these problems, but since most of them demand certain amounts of control, materials that can be carefully applied are desirable. These might include pen and ink, fiber-tipped pens, felt markers, ball-point pens or pencils. Do not rule out brushes and paint or ink. Go with what seems to work best after experimenting with several ideas.

4

1

Op Art Problems

Optical art is an art of essentials. It relies on complete abstraction, and while some problems involve a pure scientific approach, others might involve more feeling and freedom. But whatever the initiating force, the result is an eye teaser — or it is not optical art.

Straight lines looked curved, moiré effects are achieved, the lines wriggle and the flat surfaces undulate. The eye often cannot focus and is stretched, flattened and tricked into seeing things which just are not so. And it all has a scientific reason for happening.

Working within the confining restrictions of such a scientific approach is often a welcomed shift in style. If you delight in the detailed and careful aspects of drawing you will find much motivation in these problems.

While the illustrations offer only a few of the hundreds of problems possible, they are a start. Measurement is important. A change in size and distance produces a variety of effects. Moirés, are achieved by overlapping some patterns. Look carefully at op compositions and devise experimental problems from them. Compasses, rulers or protractors are necessary in getting the desired results. Neatness and exactness are essential to *most* good op drawings.

1 *Concentric circles (varying in spacing) combined with lines radiating from the center, provide the space divisions in this drawing. Fiber-tipped pen, 12 inches in diameter.*

2 *Converging lines and shapes produce a vortex feeling. Pen and ink, 14 x 10.*

3 *Straight lines appear to produce curved shapes in this drawing. Making some lines closer together than others produces this effect. Fiber-tipped pen, 12 inches square. All drawings on this page are from Lutheran High School, Los Angeles.*

4 *This experimental op drawing uses several separate visual techniques in a single work. Pen and ink, 16 x 12.*

5 *Zebra stripes continue past the contour of the running animal. Alternate shading of spaces produces a feeling of line around the zebra. Pen and ink, 12 x 16.*

116

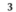

3

4

5

S. WALKER

1

Pop Drawing

While the term *op art* applies to a definite character and type of work, *pop art* (a relatively undefinable term) covers a greater range of styles and has more to do with a feeling than a change-less product. It is a world of the commonplace and the pleas-ant, and of empty and often bland subject matter. Pop draw-ing covers a range from magic realism to pure abstraction, from organically patterned drawings to experiments with materials and surfaces. With an emphasis on fads and styles, pop drawing can take off in almost any direction, as demonstrated on these pages. It is in the combination of materials and subject matter that the realm of pop art is explored.

Most pop drawing contains a stylization and search for sim-plicity, with hard edges and outlines in black line. Subject matter is varied. Other pop drawings can be photographically "real," made to look like enlarged black and white photos — purposely. Others can make use of new and exotic materials to give a "now" feeling. Offshoots of pop art (like art deco) will continue to happen every few years, and working in these styles updates drawing, which is the oldest of the visual art forms. Exploration and experimentation are the keys to exciting work in an area of art directly related to the spirit of a time and place.

Surrealism

If you are interested in surrealistic approaches to drawing, you should spend a bit of time studying its history and some of the artists. Any media is satisfactory, but the subject matter is the major ingredient. Usually, surrealistic drawings are carefully rendered, often of common subjects but in illogical combinations or situations. The refined quality of the drawing itself is part of the feel of a surrealistic work. Illustrations of dreams, dream sequences or dream-like subjects are excellent way to begin. Elaborate doodles might also be considered surreal in their exposing of inner feelings or thoughts.

4

3

1 *The kitchen sink is a pop subject and the drawing treatment emphasizes it. Pen and ink, 18 x 24. Gardena High School, California.*

2 *Loc Rite Spl., Donald Hendricks. Pencil, 16 x 20. The black and white photo is commonplace, and this pencil drawing wants to look like a black and white photo. Tone and value are painstakingly done to enhance the feeling. Courtesy, Orlando Gallery, Encino, California.*

3 *Personal symbolism is characteristic of surrealist drawing, but each object has a reason for being visualized. Ink and wash, Kentridge High School, Kent, Washington.*

4 *Intricate detail and a personal statement characterize this surrealistic pen and ink drawing. It is 18 x 12 in size, from Lutheran High School, Los Angeles.*

1 *Surrealist auto drawing by Roger Kutz. Pencil and charcoal, 24 x 39. Human elements are mystically combined with the machine. The topic is complex, but perspective and finished work are accurate and polished. Courtesy of the artist.*

2 *A surrealist drawing of plants, bugs and magical creatures reveals a decorative but complex organization. Pen, brush and ink, 16 x 22. Nightingale Junior High School, Los Angeles.*

3 *Cross, Gordon Hines and a Canadian computer, 31 x 31. Designs produced by computer plotters resemble op art in many respects. There is a high degree of control with the computer. Courtesy, California Computer Inc., Anaheim.*

4 *Two machine drawings by Paul Allen. Ink, about eight inches long. The artist worked for many years to develop a machine that would draw lines while being influenced by gravitational fields. These drawings by the artist and the machine are not planned ahead of time, but just happen. Courtesy of the artist.*

Drawing Machines

How man uses his tools (pens, brushes, pencils) is a record of society's progress, and his aesthetic endeavors with those tools measure the quality of that progress. Technology in our day has produced some amazing tools, and some of the most improbable, like the computer, have been put to artistic work. The creative programmer uses computer plotting systems to produce drawings. In this way he tries to bring man and machine closer together — and perhaps humanizes the machine a bit. These computer-generated graphic images may offer some suggestions for drawing ideas. Even though they may not be possible to produce in a classroom, they are a part of the on-going drawing continuum from cave renderings to the present.

Computer artists use huge and complicated machines to program their drawings, but some men, like Paul Allen, have built their own drawing machines. His works on the basic principle of gravitational fields, and the beautiful lines his machine produces are practically self-created. You may wish to explore the possibility of producing your own drawing machine.

3

4

4

1

2

3

4

5

122

FROM A (IS FOR ABSTRACT) TO Z (IS FOR ZOO)

New drawing problems are probably invented by the hundreds every day, by creative students and teachers all over the world. And any book will list only a small fraction of them. What do you do with animals, or designs, or special techniques, or strange subject matter, or number and letters?

Perhaps the examples shown in this chapter will give you a clue to things that can be done. Take off in all directions in any media and on any subject, from A to Z. Some drawings are sheer fun, others offer opportunities for much growth. Some are visual records and reportings, others are classic examples of enthusiasm and excitement.

Work on drawing problems where your special interests can be explored and expanded. If you enjoy drawing horses, cars, boats or clowns, work on those subjects that are your favorites. Be sure you are not treading water, but are growing and expanding your awareness by trying new approaches, new additions and different media.

1 *Pets have to be observed carefully for a long period of time; they do not hold such positions for enough time to finish a drawing. Pen and ink, from Fremont High School, Los Angeles.*

2 *Special interests should be sought out and exploited whenever possible. Fiber-tipped pen, pen and ink and acrylic paint, 24 x 36. Lutheran High School, Los Angeles.*

3 *A pencil drawing that simply explores the pencil and the kind of lines it will make. The rhythm and movement are strong features, but the pencil is the star. Baltimore City Schools, Maryland.*

4 *An abstract mixed media drawing that expresses the pure joy of line and value. Pen and ink, pencil and white conté crayon on gray paper, 18 x 24. John Marshall High School, Los Angeles.*

5 *Stuffed birds and animals make excellent material for drawing studies, as well as finished work. Fiber-tipped pen, 15 x 24. Hollenbeck Junior High School, Los Angeles.*

6 *A familiar subject can be shown in some interesting ways. Pencil, 12 x 18, Hollenbeck Junior High School, Los Angeles.*

7 *With a movie camera and a bit of imagination, animated movies can be created from drawings. The first step is making the story board, which is really the outline around which the rest of the drawings hinge. Reseda High School, California.*

1

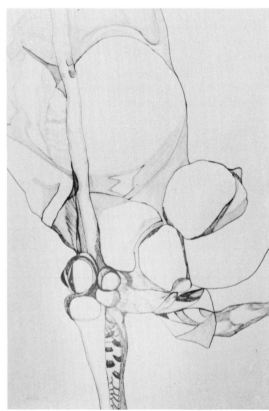

2

3

Abstract and Cubist Drawings

Abstract drawing can be approached from several directions. It can be developed from the design approach, using abstract shapes, lines, patterns and/or textures and building up the drawing. Or the work can start with recognizable subject matter and be abstracted until a distillation is left. Both are valid and both produce exciting results. Exploration is the important word. Try any method that occurs to you to help students see and draw lines and shapes in an abstract format. A bit of discussion centering on types of abstraction and known abstract painters will be helpful in the beginning.

One form of abstraction might involve cubist techniques: breaking up shapes, rearranging parts, using multiple views and contour continuation. Each approach opens another door to design awareness and provides another drawing challenge. Explore the work of Georges Braque, Pablo Picasso, Juan Gris and other cubist-oriented artists. Observe how they drew and painted their subject matter and then see what new ways you can find to draw yours.

4

1 *A student model is drawn and fractured in a cubist style. Lines and edges are straight wherever possible and often continue to the edge of the page (contour continuation). Tone is kept to a minimum. Black crayon, 24 x 18. Birmingham High School, Van Nuys, California.*

2 *Abstract organic shapes (suggestive of bones) are carefully placed to make a handsome composition. Pencil and pen, Fremont High School, Los Angeles.*

3 *A black crayon drawing, abstracted from a seed pod arrangement. See page 125 for development of this problem. Lutheran High School, Los Angeles.*

4 *Breaking up shapes and displacing them a bit is a cubist technique, as is the transparency of still life objects. Pencil and watercolor wash, 24 x 18. Reseda High School, California.*

5 *A problem in abstracting: 1, a realistically shaded drawing of a bunch of keys; 2, a contour drawing of the same keys; 3, (upper left) a crayon drawing (18 x 24) using only a simplified small part of the contour drawing, but greatly enlarged; 4, an imaginative pen and ink drawing, based on the shapes in no. 3, but not relying on the previous drawings in any way except for shapes or suggestion. Lutheran High School, Los Angeles.*

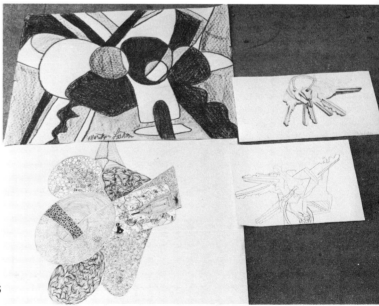

5

125

1

Animals, Birds and Insects

Three sources are available for subject matter on the animal scene: live, stuffed, and flat reproductions. All offer points of departure for effective drawing in any medium. Drawing animals offers the opportunity to expand your experience beyond the human figure. Accurate animal drawings can only be done after hundreds of sketches. But, in the art class it is the experience that is important, not the end product.

Seldom can live animals be brought into the classroom. It is often more convenient to go where the animals are — the zoo. Since it is impossible to get wild animals (and even pets) to pose, you should watch the movement of the animals for a while and then begin to sketch. Gesture type drawings will familiarize you with the major shapes and movements, and then more careful observations can be recorded. Pets can be drawn at home, at times when they are quiet. Animals at the zoo are most relaxed and quiet right after feeding.

Stuffed animals, posed in action positions, make excellent models. They can be found in natural history museums and sometimes in local museums. These same museums will often rent animals or birds to schools for a year at a time. Your school's biology department might have some stuffed animals and birds that can be borrowed, or some students might be able to bring some from home. Insects can also be borrowed from biology departments or student collections, and observed under a magnifying glass if necessary.

Photographs of animals, birds or insects can provide still another source for drawing. Care should be taken not to imitate the photograph, but to use it as a point of reference and source of information. This is the least desirable method of drawing animals, but in many cases it is the only source available and should not be disregarded.

2

3

4

1 *A nearly dry, fiber-tipped pen is used like a pencil by George James. Black negative shapes add strength to the sketches, which show goats at rest. Notice how lines are used to generalize shapes and also to create form. Courtesy of the artist.*

2 *A trip to a natural history museum will give you a chance to sketch animals that are not active. These quick contour drawings are done with a thick pencil on 18 x 24 inch newsprint. Lutheran High School, Los Angeles.*

3 Dinner Time, *Lois Green Cohen. Wash and ink, 18 x 24. A sensitive drawing that combines wash and line to create the textures of the animals. Careful observation is necessary, as is attention to characteristic details. Courtesy, Emerson Gallery, Tarzana, California.*

4 *A single stuffed bird is drawn in contour from four angles and overlapped in places. Some of the areas and shapes produced are filled in, others are left white. Pen and brush and ink, 18 x 24. Lutheran High School, Los Angeles.*

5 Baby Chimp, *Lois Green Cohen. Washes and brush and ink, 19 x 13. Animals should be animated (look alive), even when resting. Courtesy, Emerson Gallery, Tarzana, California.*

6 *An imaginary beetle provides the subject matter for an experimental drawing. There are several layers of illustration board, with shapes cut out, and drawings showing in the "windows." Ink and wash, Concordia Teachers College, Seward, Nebraska.*

5

6

1

2

3

128

Calligraphy and Numbers

Our senses are bombarded with words and numbers in an unbelievable variety of ways, but seldom do we experiment with these visual symbols. While lettering, in the traditional sense, can become tedious after a time, some fresh ideas can spark a new approach to the use of letters and printed words.

Pictures can be made from words, or designs using letters can be worked out. Calligraphy can provide textures. Try weaving a calligraphic line of words into a drawing or build an abstract pattern with letters or parts of letters or numbers. Delve into the abstract qualities of words or letters. Notice the rhythm developed by letter repetition and the texture produced by overall patterning.

Explore ways to work with letters or numbers. Observe how the advertising industry makes use of words. Expand these ideas in stimulating drawing problems. The letters and designs in industrial logos or trademarks can provide some interesting ideas for drawings.

The medium should be chosen to suit the purpose of the drawing. Charcoal or pencil can be used where sharp edges are not necessary, but fiber-tipped pens or pen and ink are probably the most useful.

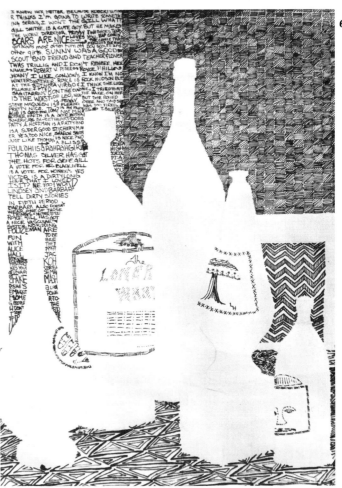

1 *Try to express a feeling in the way you put down the word. Make the style express the same thing as the word. Pencil, brush, felt-tipped pen, each about 12 inches long. Lutheran High School, Los Angeles.*

2 *Combine drawing with calligraphy in a different way — have the line of lettering meander around the sketch. Pen and ink, 18 x 12. San Fernando High School, California.*

3 *Sketchbook pages are great places to work on lettering style. Pen (Rapidograph) and ink, 11 x 8½. Lutheran High School, Los Angeles.*

4 *Take any letter (or student initial) and work out a design, varying the letter size for interest and to avoid monotony. Pen and ink, 10 x 14. Lutheran High School, Los Angeles.*

5 *Design made up of letters and words, with various patterns used in different parts of the drawing. Pen and ink, 14 x 20. Paul Revere Junior High School, Los Angeles.*

6 *Lettering and words are used (upper left negative area) as texture behind the positive shapes of the bottles. Pen and ink, 24 x 18, Reseda High School, California.*

Skulls and Skeletons

Bones of all sizes and shapes, from rodent skulls to a cow's back-bone, provide most interesting groups of forms to draw. They are organic, vary with each animal, are readily obtainable (at least in rural areas) and can be arranged at will. They can be drawn individually and close-up or in still life groupings. They can be worked realistically in pencil, impressionistically with wash, or designed with pen and ink. Human bones can be borrowed from the biology department (even a whole skeleton) and fascinating studies in line and value can follow. A sketching trip to a museum of natural history should provide an unending supply of models from which to work.

1 *Such drawings might take long periods of time to finish, but the knowledge gained is worth the effort. A seated skeleton is more fun to draw than a dangling one. Ink and wash, 24 x 18. Gardena High School, California.*

2 *The hardness of skull bones is emphasized, in a still life, if placed against a soft cloth.*

3 *A single hand of a human skeleton can be material for an intriguing design. Notice the variety of pattern. Pen and ink, 12 x 12. Paul Revere Junior High School, Los Angeles.*

4 *Drawings on this bulletin board were all derived from magazine photos. Blacks were made black, whites were left alone, and grays went either to black or white, depending on the depth of their values. Pen and brush and ink, each drawing is 12 x 12. Lutheran High School, Los Angeles.*

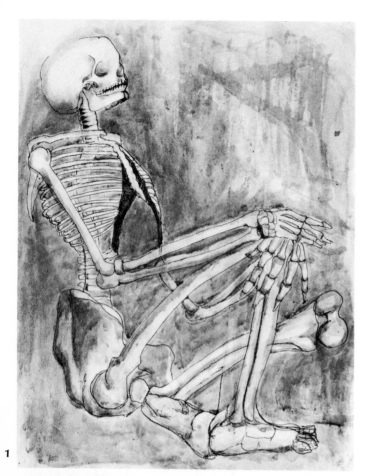

1

2

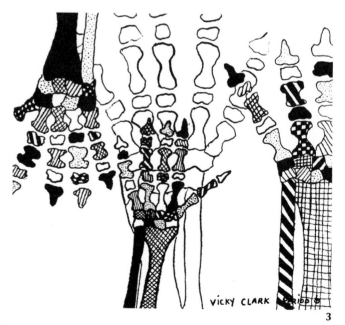

VICKY CLARK

3

Using Photographs Creatively

Photographs or black and white magazine reproductions should never sneak into the art room. *Not true!* The photo or print is not the problem; it is what we do with them. Exploding a photograph by drawing past the edge of the picture is an excellent study for value contrast and often for perspective. Quick sketches, made from magazine photos, again provide an excellent source of value exercises. Awareness of proportions and values is strengthened in problems involving the duplication of a black and white photo collage.

Photographs used as sources of information and points of departure can be valuable aids. There is hardly a commercial artist or illustrator working today who does not use photography in his/her work. Try to find new ways of using photographs by sketching, simplifying, working with values, dropping our gray areas or other exciting possibilities. As long as you are constantly learning to see more accurately, your work with photographs can be worthwhile.

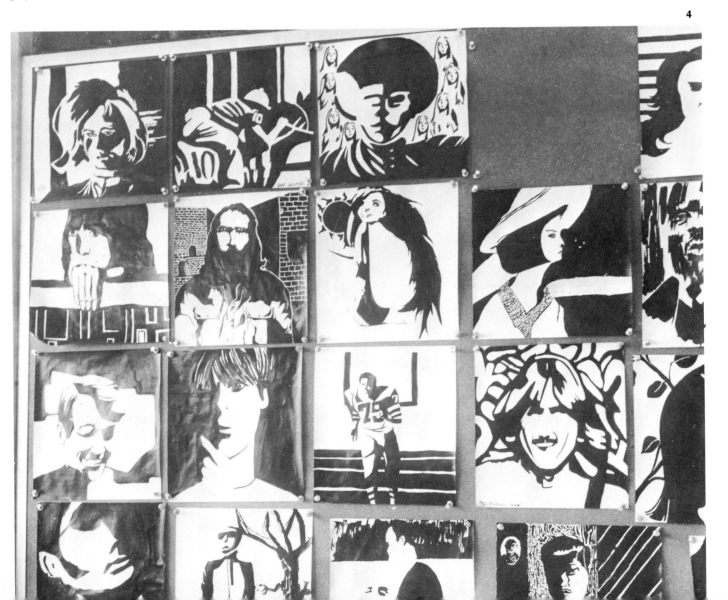

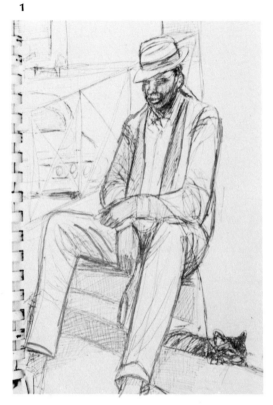

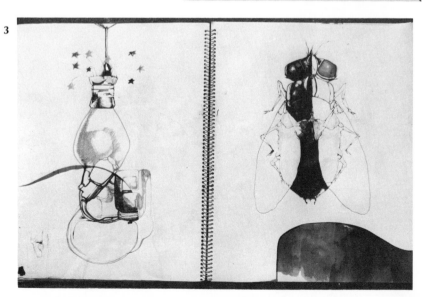

THE SKETCHBOOK

Many artists keep sketchbooks the way authors keep diaries to record any and all impressions that need to be stored for future use. They are visual diaries of trips, people, friends, walks, vacations or daily happenings around them. They can be paged through for ideas, consulted to recall information, or referred to for details or color notes.

The sketchbook pages are excellent places to "trouble shoot" or get extra practice on those features that are giving you trouble, such as hands or eyes. Work from models, friends, in class or from a mirror. Keep working until the need for drawing that subject passes, then move on to another area.

Sketchbooks should contain visual thinking — thoughts and rehearsals on paper — and not much finished work. The act of drawing in the book is important, not the drawings. If you work too long at a sketch and fall in love with it, you will not want to develop other sketches of the same subject, or work on that idea at length again. There might be some great finished "on-the-spot" drawings, but they should be fortunate happenings and not necessarily planned. Practice ideas in the book, make dozens of thumbnail sketches, try out new techniques, doodle, work out patterns for paintings, just simply visually record your growth in looking and seeing.

4

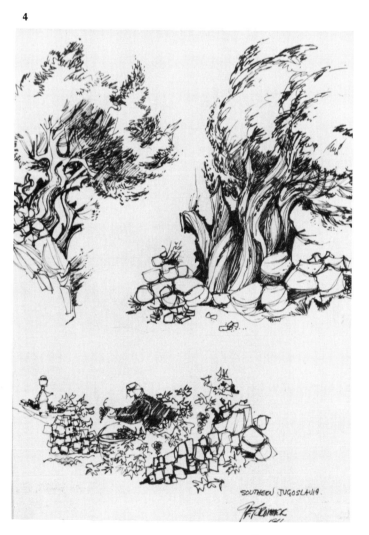

SOUTHERN JUGOSLAVIA.

1 *Relaxing friends and neighbors make good sketchbook studies. This page is from a Fremont High School (Los Angeles) sketchbook.*

2 *Joseph Mugnaini explores several aspects of an idea on a page of his sketchbook. Such working and visual thinking will often lead to a finished drawing or painting. Courtesy of the artist.*

3 *Cutouts, collages, idea drawings and forceful observations can be conveniently combined in sketchbooks. These are wash and ball-point pen drawings from the Los Angeles City Schools Special Scholarship Classes.*

4 *Studies in various amounts of detail can be incorporated later in many painting situations. Fiber-tipped pen drawings from the author's 8½ x 11 sketchbook.*

1 *Sketchbooks are places to practice drawing and to record observations — at home, in school, on vacation, anyplace. These 8½ x 11 pages are from Lutheran High School (Los Angeles) sketchbooks.*

2 *Lecture notes (in art class or otherwise) are often augmented with meaningful sketches of teachers and fellow students. Lutheran High School, Los Angeles.*

3 *Sketchbooks are perfect places to practice your seeing and recording techniques. Contour drawings such as this are excellent items to include. California State University, Fullerton.*

1

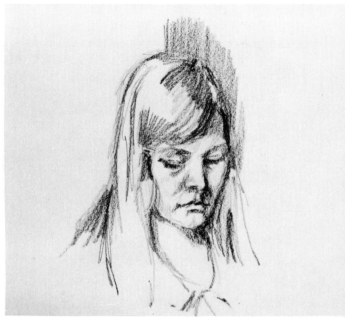

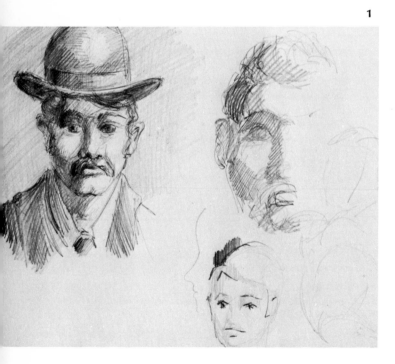

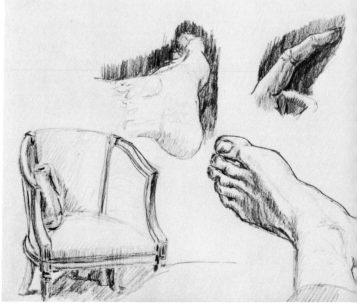

Your sketchbook can be a valuable asset to you as a student artist if it provides these features: 1) keeping visual notes for future use, 2) practice drawing subjects that might give you trouble, 3) be a place for visual thinking, 4) a place for doodling and day dreaming.

People in the Sketchbook

Sketchbooks are wonderful places to record observations of people at rest or in action. Physical education classes, study halls, the library, the lunch area or the art room are full of exciting subject matter. If that does not appeal to you, try places where people gather to wait such as the post office, air terminals, doctor's office, bus stations, bus stops, the movies or the beach.

Try sketching members of your family while they are watching television, reading, sitting on the steps, working in the yard or lying in the sun. Look around your neighborhood for subjects, or go to the ball game.

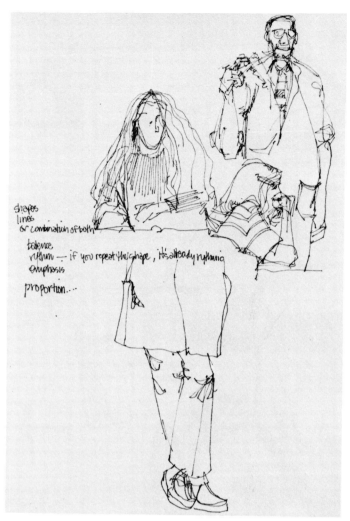

2

3

Be as casual as possible, sitting off to the side, looking and recording. If onlookers at school or on the street give you problems, close your book and move on. Most artists have developed ways of blending into the background so they can work relatively unnoticed.

Work on faces or hands or feet until you feel easy working with them. The sketchbook is the place to record this practice. A look back over several books should be a diary of growth in seeing and recording.

1 *The sketchbook is the place to record your practice in drawing faces.*

2 *Family and friends can be constantly recorded.*

3 *Your own feet (with shoes or without) and hands (movement study) are easy to record in your book. These are from the Los Angeles City Schools Special Scholarship Class which does almost all of its work in sketchbooks.*

4 *Be selective in your line studies, depending on your feeling at the moment — what you wish to emphasize. Fiber-tipped pen drawings from the author's sketchbooks.*

5 *Work in the sketchbook need be only partially completed, since drawings there are meant to be studies. Ball-point pen drawing, Los Angeles City Schools Special Scholarship Class.*

1

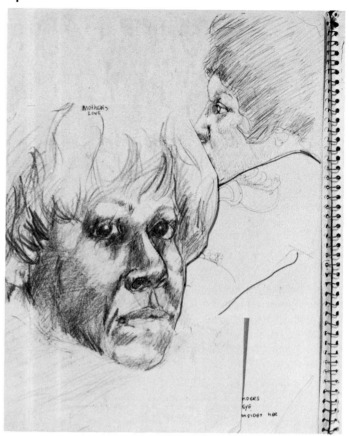

2

3

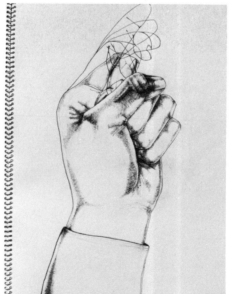

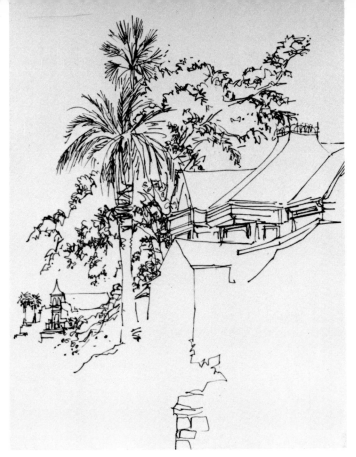

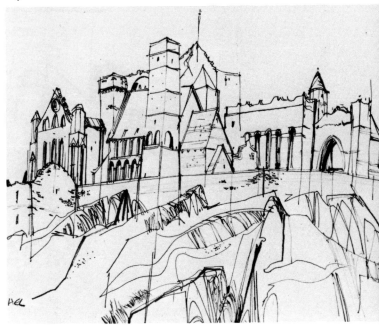

Places and Things in the Sketchbook

For artists that work at landscape painting, sketchbooks are indispensable; and for art students fascinated by their environment, they are essential. Travels, whether on another continent or to the city park, can be recorded visually in sketchbooks. Artists who do much traveling have shelves full of such records. And, aware art students will record their surroundings and experiences in the same way.

Machines, animals, or objects of any description that constantly surround us are fair targets for the artist. Birds and insects alike should be observed and drawn. Sometimes you will need a magnifying glass.

Ideas and thoughts can be visualized, and the sketchbook should record the entire process from beginning to end. Looking back on the progress of an idea might later provide further ideas for development. If such a thinking-drawing process is put on scrap paper, it is usually misplaced after a while and serves no further purpose. Sketches that are saved might be useful years later in completely different circumstances. Things done on scrap paper should be taped or glued into the sketchbook.

The sketchbook is a most valuable resource book, if it is kept going and growing and used.

1

1 Variations on David, *Howard Warshaw. Charcoal, pencil, wash, white tempera and collage, 12¼ x 22. Artists often make many draw-ing studies before beginning a painting, because they can solve com-position and value problems before a brush is put to canvas or wall. Collection, Los Angeles County Museum of Art, gift of Dr. and Mrs. Maximillian Edel.*

2 *Perspective needs to be discussed in connection with still lifes as well as with cities. Pencil, 18 x 24. Lutheran High School, Los Angeles.*

12

SOME FINAL THOUGHTS

To review the nearly 300 illustrations reproduced on the previous pages would be an exhausting experience. Many of them are extremely competent, others are the recordings of young artists in search of methods of working and recording what they see. But all are valuable visual experiences, both for the artist and the viewer. The search must go on, in each individual in each class in each school in the country. Perhaps many of these ideas will help that search become more pleasant and meaningful for you.

Several random thoughts might be explored before the final pages are turned. Probably the best drawings result when you are relaxed and at ease. An alertness to *what* you are seeing is desirable, but over-tenseness will cause your lines to be mechanical and not responsive to what you are observing.

Do not get discouraged over drawings that do not seem *right* to you. The fact that you are looking carefully at things and recording what you see is of great importance. Do not worry if your drawing does not look like that of your neighbor or like some great masterpiece that you have seen. The important thing is that you are looking and seeing and drawing.

Draw frequently! Be on the lookout for new subjects! Develop an awareness of things around you: big things, small things; inside and outside; whole objects and small details; landscapes, people, paintings, sculpture, and other drawings. From this *looking* and *seeing*, unlimited subject matter for drawing will evolve.

Keep looking, experimenting, innovating and drawing!

It is true that the most important way to learn to draw, is to draw. But at times there are problems that really stump both teacher and student; and at other times it is refreshing and inspiring to check out the work of other artists and students. The prime sources for these answers are in museums and galleries — and in books. There are a very large number of drawing books on the market, and most of them will offer you some help. The following list has been carefully compiled, all of these books being very useful for one purpose or another. There are undoubtedly more that are helpful, but cannot be included here. If you are interested in books that offer ideas or techniques, the following are among the best available:

2

BIBLIOGRAPHY

If you are interested in books that offer ideas or techniques, the following are among the best available:

History of Drawing

DRAWING LESSONS FROM THE GREAT MASTERS
Robert Beverly Hale. Watson Guptill Publications, New York. One hundred master drawings are shown and analyzed — with applications to drawing techniques.

DRAWING
Daniel M. Mendelowitz. Holt, Reinhart and Winston, Inc., New York, 1967. A lengthy and complete source book on drawing: history, the art elements and media. Valuable discussions of each drawing that is illustrated.

MODERN PRINTS AND DRAWINGS
Paul J. Sachs. Alfred A. Knopf, New York, 1954. A fine historical account, well illustrated, of the development of the graphic arts, drawing and printing for the past century.

Drawing Media

DRAWING IN INK
Harry Borgman. Watson-Guptill Publications, New York, 1976. Very comprehensive treatment of all ink drawing techniques, especially line and texture. Many superb examples.

LANDSCAPE PAINTING WITH MARKERS
Harry Borgman. Watson-Guptill Publications, New York, 1974. Illustrations and techniques using a great variety of markers and pens. Cities and natural landscapes are used as subject matter.

THE PENCIL
Paul Calle. Watson-Guptill Publications, New York, 1974. Contemporary use of pencils in dynamic illustration techniques. Outstanding examples of people and athletes in action and of space activity.

PASTEL
Daniel E. Greene. Watson-Guptill Publications, New York, 1974. Complete instructions in using colored pastels in many techniques. Many excellent illustrations.

DRAWING WITH PEN AND INK
Arthur L. Guptill. Reinhold Publishing Co., 1961. (Revised edition). Explanation and instruction in all aspects of pen and ink work. Many valuable illustrations.

PENCIL DRAWING STEP BY STEP
Arthur L. Guptill. Reinhold Publishing Co., 1959. Complete coverage of the many techniques of pencil drawing.

RENDERING IN PEN AND INK
Arthur L. Guptill. Watson-Guptill Publications, New York, 1976. An encyclopedia of ink drawing techniques, both for the learner and the professional artist. Discusses all available books, materials and techniques, with many illustrations.

RENDERING IN PENCIL
Arthur L. Guptill. Watson-Guptill Publications, New York, 1977. Edited by Susan Meyer. All the elements of drawing with pencil, including many detailed illustrations and examples.

CREATIVE PENCIL DRAWING
Paul Hogarth. Watson Guptill Publications, New York, 1967. The artist-author explores and explains his own approach to pencil drawing.

CREATIVE INK DRAWING
Paul Hogarth. Watson Guptill Publications, New York, 1968. Fascinating text and more fascinating illustrations in Hogarth's unique style, from tools to specific types of drawing.

DRAWING WITH PENCILS
Norman Laliberté and Alex Mogelon. Van Nostrand Reinhold Co., New York, 1969. A brief history of pencil drawing followed by demonstrations and illustrations of the Laliberté technique.

CHARCOAL DRAWING
Henry C. Pitz. Watson-Guptill Publications, New York, 1971. Many visual examples complement a complete text on using charcoal in all techniques.

INK DRAWING TECHNIQUES
Henry C. Pitz. Watson Guptill Publications, Inc., New York. Fundamental handbook on all methods of drawing with pen, brush and ink.

THE ART OF PENCIL DRAWING
Ernest W. Watson. Watson Guptill Publications, Inc., New York, 1968. Traditional drawing techniques beautifully displayed and described — mostly for the on-the-spot artist.

General Drawing Books

LEARNING TO DRAW
Robert Kaupelis. Watson Guptill Publications, New York. Projects to develop observation and creativity in drawing.

ON-THE-SPOT DRAWING
Nick Meglin. Watson-Guptill Publications, New York, 1969. Twelve illustrators share their work and ideas with you, presenting outstanding examples of their various drawing techniques. Many subjects are illustrated.

Female Portrait in Profile with Flowing Hair, *Man Ray. Ink and wash drawing, 10 x 14. Artists have developed individual styles over years of working, and regardless of media, that style shows in all their work. Collection, Los Angeles County Museum of Art, gift of Frank Perls Gallery.*

DRAWING, A STUDY GUIDE
Daniel M. Mendelowitz. Holt, Rinehart and Winston, Inc. New York, 1966. A variety of drawing activities that challenge the student. Eighty-five projects outlined, described and pictured.

THE HIDDEN ELEMENTS OF DRAWING
Joseph Mugnaini. Van Nostrand Reinhold Co., New York, 1974. A dynamic approach to drawing, that helps the artist realize the whys and wherefores of drawing. Emphasis is on the figure, but other subjects are also treated.

THE COMPLETE DRAWING BOOK
Peter Probyn, editor. Watson Guptill Publications, New York, 1970. Every phase of drawing is covered, each chapter by a different artist. Loaded with illustrations.

DRAWINGS BY HIGH SCHOOL STUDENTS
Beatrice T. Thompson. Reinhold Publishing Co., New York, 1966. Illustrates the kind of work that can be accomplished with good lessons and fine direction.

Special Drawing Interests

PERSPECTIVE: SPACE AND DESIGN
Louise Bowen Ballinger. Van Nostrand Reinhold, New York, 1969. Perspective, from basic concepts to technical aspects, is explained and diagrammed.

THE ARTIST'S SKETCHBOOK AND ITS USES
Rex Brandt. Reinhold Publishing Co., New York. Shows how to keep visual records in your book and provides ideas from many artists' sketchbooks.

THE ARTIST AS REPORTER
Paul Hogarth. Reinhold Publishing Corp., New York, 1967. A paperback analysis of the art of visually reporting history as it happens.

CARTOONING
George F. Horn. Davis Publications, Inc., Worcester, Mass., 1965. Insight into the whys and wherefores of contemporary cartooning. An excellent reference to give ideas to the special student who needs it.

THE ANIMAL BOOK OF BOB KUHN
Bob Kuhn. Watson-Guptill Publications, New York, 1973. Fine examples of the artist-author's methods of working with animals. Generously illustrated.

ALEXANDER CALDER'S ANIMAL SKETCHING
Charles Liedl. Sterling Publishing Co., Inc., New York, 1972. Illustrates the quick but forceful line drawings of one of America's great artists. Many delightful examples.

OPTICAL ART
Rene Parola. Reinhold Book Corp., New York, 1969. A complete analysis of this fascinating art movement with many pictures of work done by the author's students.

HOW TO DRAW TREES
Henry C. Pitz. Watson-Guptill Publications, New York, 1972. Illustrates the characteristics of all American trees, with detailed examples to help you draw them. Contains gallery section on trees drawn by many other artists.

THE ART OF SKETCHING
Albert W. Porter. Davis Publications, Inc., Worcester, Massachusetts, 1977. Exciting examples of how many artists work in their sketchbooks, helping you to understand how they see their subjects.

Figure Drawing

FIGURE DRAWING COMES TO LIFE
Calvin D. Albert and Dorothy G. Seckler. Van Nostrand Reinhold Co., New York, 1957. A series of experiments in drawing the figure — many ideas.

BRIDGMAN'S COMPLETE GUIDE TO DRAWING FROM LIFE
George B. Bridgman. Sterling Publishing Co., New York. Over a thousand sketches by this artist-author to illustrate every aspect of figure drawing.

DRAWING PORTRAITS
Douglas Graves. Watson-Guptill Publications, New York, 1974. Excellent examples of men, women, children and groups done in pencil, chalk, charcoal and conté crayon.

DRAWING OF THE HAND AND ITS ANATOMY
Joseph Heninger. Borden Publishing Co., Alhambra, California, 1973. Many specialized exercises in drawing hands and arms.

DRAWING DYNAMIC HANDS
Burne Hogarth. Watson-Guptill Publications, New York, 1972. Hundreds of excellent drawings showing movement, anatomy and structure of the human hand in action and at rest.

DRAWING THE HUMAN HEAD
Burne Hogarth. Watson Guptill Publications, New York, 1967. Three hundred drawings to show how the head looks, from top to bottom, from young to old. Excellent reference.

DYNAMIC FIGURE DRAWING
Burne Hogarth. Watson Guptill Publications, New York, 1970. The author-artist is a master at his craft and draws the human figure in hundreds of active positions. A great reference work.

DRAWING: A SEARCH FOR FORM
Joseph Mugnaini and Janice Lovoos. Van Nostrand Reinhold Co., New York, 1965. Superb illustrations are featured, and the text is concise and meaningful. Other drawing included, but stress is on the figure.

FACES
Jack Selleck. Davis Publications, Inc., Worcester, Massachusetts, 1977. A resource book that includes drawings, paintings, prints, sculpture and photography of hundreds of faces. Visually shows how artists and craftspersons, from ancient to contemporary times, have interpreted the human face.

Landscape and City Drawing

THE ARTISTS SKETCHBOOK AND ITS USES
Rex Brandt. Reinhold Publishing Co., New York. Most of the author's references are in connection with landscape drawing. Many valuable illustrations show the selectivity necessary in landscape work on the spot.

LANDSCAPES
Gerald F. Brommer. Davis Publications, Inc., Worcester, Massachusetts, 1977. A resource book that shows how artists and photographers, both past and present, see and interpret the natural environment.

DRAWING AND PAINTING THE CITY
Mario Cooper. Reinhold Publishing Corp., New York, 1967. Mostly drawings that graphically illustrate the artist's ability to simplify and select when working in a basically complex environment.

DRAWING BUILDINGS
Richard Downer. Watson Guptill Publications, New York, 1967. Paperback discussion in detail of techniques and problems in portraying the city, mostly London.

CITIES
Joseph A. Gatto. Davis Publications, Inc., Worcester, Massachusetts, 1977. A resource book that helps you see not only the buildings of the cities of the world, but also their people. Many examples of how artists and photographers see and interpret their urban environments.

GLOSSARY

abstract art a style of art that shows objects, people, and/or places in simplified arrangements of shape, line, texture and color, often geometrical. Sometimes abstract refers to *non-objective art.*

Abstract Expressionism a twentieth-century painting style that tries to express feelings and emotions through slashing, active brush strokes. Often called *Action Painting.*

aerial perspective a way of drawing that shows depth in space by such methods as overlapping objects, using lighter values for more distant objects, using less detail in distant objects and using warm colors for nearer items.

anatomy the structure of the human body (can also mean the structure of animals or plants). Anatomical drawing often shows such details as muscle and bones.

architect a person who develops plans for buildings, groups of buildings, communities, etc.

architecture the design of buildings, such as homes, offices, schools, industrial structures.

asymmetrical balance a type of visual balance in which one side of the composition appears different than the other side while remaining balanced with it. Visually equal without being identical.

Avant Garde Art the style of contemporary art in any period of time. It is the newest form of visual expression, and farthest from the traditional ways of working.

balance a principle of design that refers to the equalization of elements in a work of art. There are three kinds of balance: symmetrical (formal), asymmetrical (informal), and radial.

Baroque a period of time and style of art (1600's) that stressed swirling action, large works of art and elaborate detail and richness, even in drawing.

Bauhaus a German art school, begun in 1918, that stressed science and technology as major resources for art and architecture.

bister (or bistre) a brownish pigment (color) made from the soot of burned word, used as an ink and in wash drawings.

block out materials materials such as rubber cement, Miskit, and Maskoid that block the application of pigments from certain areas of the background. Later, they are rubbed away, leaving an underneath layer or the background exposed in those areas.

broad strokes using the sides of drawing materials (charcoal, graphite, crayons, pastels) to make wide markings on paper.

calligraphy is really handwriting, but, in drawing, refers to lines that have the quality of beautiful handwriting (calligraphic lines) and/or brushed lines that are similar to Oriental writing.

caricature a drawing (usually of a person) which exaggerates selected characteristics of the subject (such as a prominent chin, large eyes, etc.). Often the drawings are humorous.

cartoon a full-sized drawing or pattern for another work of art, such as a mural, fresco, mosaic or tapestry.

cartoon a drawing (often for publication) that symbolizes or caricaturizes a person or event. Animated cartoons are drawings that are placed on film to create the illusion of movement.

chamois a soft leather (from a Eurasian antelope) that is used in charcoal and pastel drawing to smooth shaded areas.

cityscape a painting or drawing that uses elements of the city (buildings, streets, shops, etc.) as subject matter.

collage a technique in which the artist glues material such as paper, cloth or found materials to some type of background.

color an element of design that identifies natural and manufactured things as being red, yellow, blue, orange or any other name that identifies their hues.

complex composed of many interconnected parts.

composition the arrangement of the parts in a work of art, usually according to the principles of design.

communication the methods of letting others know what you are thinking, saying and feeling. It may be verbal, visual, musical or physical.

conceptualized art a style of painting or sculpture. The artist communicates what is known of the subject (a general idea), not how the subject actually looks. An African tribal mask is a conceptualized face.

contemporary art refers to the art of today; the methods, styles and techniques of artists living now.

continuum a continuous chain or series of events. You are now involved in the continuum of art, a chain that started in the caves of early man and continues until today.

contrast a principle of design that refers to differences in values, colors, textures, and other elements in an artwork to achieve emphasis and interest.

contour drawing a single line drawing which defines the outer and inner forms (contours), of people or objects.

conventional materials drawing tools and media that are intended for that purpose, as opposed to drawing with materials that are not intended to be art materials at all, such as electonic components.

crosshatching a method of shading with fine lines. Many parallel lines are first drawn in one direction, and are then crossed with many parallel lines in other directions to create a dense pattern.

Cubism a style of art in which the subject is broken apart and reassembled in an abstract form, emphasizing geometric shapes.

culture refers to those elements which add to the aesthetic aspects of our lives, enriching them with beauty and enjoyment.

distortion to deform or stretch something out of its normal shape.

doodling an absentminded type of drawing in which the person is often preoccupied with other thoughts.

drawing style a particular way of drawing that would define the artist or certain period of time.

elongated stretched out lengthwise; drawn in a way as to exaggerate height or length.

emphasis a principle of design by which the artist or designer may use opposing sizes or shapes, contrasting colors, or other means to place greater attention on certain areas or objects in a work of art.

engraving the process of incising lines into a surface to create an image.

expressionism any style of art in which the artist tries to communicate strong personal and emotional feelings to the viewers. If written with a capital "E", it refers to a definite style of art begun in Germany early in the twentieth century.

eye level a horizontally drawn line that is even in height with your eye. In perspective drawing, it can be the actual distant horizon line or an imaginary line, but it can also be drawn in a close-up still life.

fashion illustrator a person who draws fashion designs for advertisements in magazines, newspapers, etc.

figure drawing drawing which uses the human figure as its chief subject matter.

fixative a substance which is sprayed over charcoal, pastel or pencil drawings to make those materials adhere permanently to the paper and to prevent smearing.

form an element of design, similar to shape which encloses area, but three-dimensional (cube, sphere, pyramid, cylinder and free flowing) and encloses volume.

fragmented broken or divided into several parts. A fragmented drawing may have several separated parts that are arranged to complete the composition.

fresco a painting technique in which artists apply wet colored plaster to a wet plaster wall. A type of mural painting.

gallery a commercial enterprise that exhibits and sells art. Sometimes it may refer to an art museum.

geometric art refers to a type of art that uses lines and shapes that recall geometry: triangles, squares, rectangles, straight lines, arcs, circles, etc.

gesso a plaster-like, white material that can be brushed on a ground as an undercoating for drawings or paintings.

gesture drawing a scribbly type of line drawing that catches the movements and gestures of an active figure.

graphics refers to the art of drawing, and techniques which stress the use of lines and strokes to portray images and ideas.

graphic artist a person who designs packages, advertisements for newspapers and magazines; illustrates for ads, books, magazines; draws cartoons; designs displays and signs; produces any kind of art for reproduction.

graphite a greasy, natural carbon material that is used in making lead pencils.

ground the surface on which a drawing (or painting or collage) is done, such as paper, canvas, cardboard, etc.

hard edge refers to a style of art in which the artist uses crisp, clean edges and applies the values or colors so that they are even and flat.

horizontal line an actual or imaginary line that runs across the work defining the place where sky and earth come together.

horizontal a line or shape that lies down and is parallel to the top and bottom edges of the paper.

hue the name of a color, such as yellow, yellow-orange, blue-violet, green, etc.

Impressionism a style of drawing and painting (1875 and following) begun in France, which stresses an off-hand (candid) glimpse of the subject, and an emphasis on the momentary effects of light on color.

landscape a work of art that shows the features of the natural environment (trees, lakes, mountains, flowers, etc.).

line an element of design that may be two-dimensional (pencil on paper), three-dimensional (wire or rope), or implied (the edge of a shape or form).

linear perspective a system of drawing to give the illusion of depth on a flat surface. All straight, parallel lines receding into the distance are drawn to one or more vanishing points in such a drawing.

logo a visual design which symbolizes and stands for a company, industry or individual. It usually (but not always) uses letters, numbers or some recognizable visual element.

manuscript illumination the decorative drawing and painting that filled the illustrated pages of handwritten books in the Middle Ages.

mixed media a two-dimensional art technique that uses more than one medium; for example, a crayon and watercolor drawing.

moiré a wavelike pattern that develops when certain lines are overlapped. It occurs in some Op Art designs.

monochromatic of only one color. Most drawings are monochromatic, using one color of ink or lead.

movement a principle of design that refers to the arrangement of parts in a drawing to create a slow to fast flow of your eye through the work.

museum a place in the community where art is collected and placed on view. Works belonging to the museum are not for sale, but are for study and enjoyment.

nibs pen points, used on pen holders which provide for the removal of tips.

negative space the area around the objects in a drawing or painting, often called the background.

non-objective art art which has no recognizable subject matter, such as trees, flowers or people. The real subject matter is the composition of the drawing or painting itself.

Op Art (Optical Art) a style of art (middle of Twentieth Century) that uses optical (visual) illusions of many types. These works of art are composed to confuse, heighten or expand visual sensations.

opaque the quality of a material that will not let light pass through. The opposite of transparent.

organic free form, or a quality that resembles living things. The opposite of mechanical or geometric.

Oriental papers handmade papers from the Orient that have an absorbant quality that makes them useful for certain drawing, collage techniques and printmaking. There are many types, some having fascinating textures.

painterly quality that quality of a work of art that allows brush strokes to show and lets us see that it is really a painting.

papyrus a paper-like material (made from the papyrus plant) that was used as a writing and drawing surface in ancient Egypt, Greece and Rome.

pattern a principle of design in which combinations of lines, colors and shapes are used to show real or imaginary things. It may also be achieved by repeating a shape, line or color.

perspective drawing a method of drawing on a flat surface (which is two dimensional) to give the illusion of depth, or the third dimension.

pigment the coloring material used in painting and drawing media. Pigments may be natural (from earth, plant dyes, etc.) or from laboratory prepared chemicals.

Pop Art a style of art that features the everyday, popular things around us. A drawing of a large Coke bottle might be considered Pop Art.

positive space the objects in a work of art, as opposed to the background or area around the objects.

portrait a piece of art work featuring a person, several people or an animal. Portraits are usually facial, but can also be full figure.

Post-Impressionism the style of art that immediately followed the Impressionists, in France. Paul Cezanne was a leader of this style which stressed more substantial subjects and methods than those used by the Impressionists.

preliminary sketch a planning sketch, usually on a smaller scale, to determine the basic arrangement of a design or larger work of art.

proportion a comparative size relationship between several objects or between the parts of a single object or person. In drawing, for example, watch for the correct relationship of the size of head and body.

radial balance a design based on a circle with the features radiating from a central point.

Realism a style of art that attempts to realistically show actual places, people or objects. It stresses actual colors, textures, shadows and arrangements.

reed pens pens made from natural materials, such as reeds or bamboo shoots, which are carved to a point.

refraction the change in appearance or the visual distortion that often occurs when objects are viewed partly through water, glass or other transparent media. A spoon half in and half out of water may appear bent.

relief the raised parts of a surface which are often noticeable by the feeling of texture.

rendering the careful and complete drawing of an object, place or person, to make it appear realistic.

Renaissance a period of time (1400-1600) following the Middle Ages that featured an emphasis on human beings and their environment and on science and philosophy. A renewal of Greek and Roman thinking regarding art and humanity.

representational drawing the drawing of objects, people or places in such a way that they can be recognized for what they are.

rhythm a principle of design that indicates a type of movement in an artwork or design, often by repeated shapes or colors.

rice paper same as Oriental paper.

Rococo a style of art (1700's) following the Baroque, which featured decorative and elegant themes and style.

Romanticism a style of painting (middle Nineteenth Century) that featured adventure, action, imagination and an interest in foreign happenings and people.

rubbings a technique that transfers the textural quality of a surface to paper by placing the paper over the textured surface and rubbing the top of the paper with a crayon, pencil, etc.

seascape a drawing or painting that features some part of the sea as subject matter. It often refers to a coastal environment.

sepia a brown pigment (originally obtained from the secretion of cuttlefish) used as ink or in wash drawings. It is also the name of a brownish hue.

set-up a group of objects which are arranged to be drawn or painted. A still life grouping.

sgraffito the process of scratching lines into the surface of a work of art in order to expose the surface underneath.

shading using the drawing or painting medium to form darkened areas (shadows) that will help produce a feeling of space and depth.

shape an element of design described as two dimensional and enclosing area. Shape can be divided into two basic classes: *geometric* (square, triangle, circle) and *organic* (irregular in outline).

silverpoint a tool which has a point made of silver. It is drawn over an abrasive surface to create delicate lines which darken as they oxidize.

sketch a quick drawing. One that catches the immediate feeling of action or the impression of a place. Probably not a completed drawing, but one that may be a reference for later work.

sketch book a book with blank pages in which students and artists record visual notes of many of the things they see and imagine.

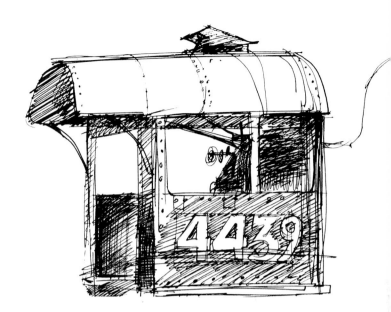

Al Porter constantly records his visual experiences in sketchbooks. This is one of a series of drawings of old train engines. Courtesy of the artist.

space an element of design that indicates areas in a drawing (positive and negative) and/or the feeling of depth in a two dimensional work of art.

spectrum the complete range of color that is present in a band of light (and seen when that light is refracted through a prism). The colors of the rainbow.

still life an arrangement of inanimate objects to draw or paint.

stippling a drawing technique (usually done with pen and ink) in which dots are made to create shaded areas or textures.

structure the constructive elements of a work of art. The underlying arrangement (foundation) of the parts of a composition.

style the distinctive character contained in the works of art, period of time or geographical location.

stylization to conform to a certain style or "look" which has developed in art.

subject matter the things in a painting about which the artist is communicating.

subtle in art, it is used to describe the delicate appearance or gradual change contained in the work of art. It is hardly noticeable, unless a person looks carefully.

Super Realism a style of drawing and painting in the late Twentieth Century that emphasizes photographic realism. Many times the objects are greatly enlarged, yet keep their photographic appearance.

Surrealism a style of twentieth-century painting in which the artists relate normally unrelated objects and situations. Often the scenes are dreamlike or set in unnatural surroundings.

symmetrical balance a design in which both sides are identical.

technique any method or system of working with materials.

texture an element of design that refers to the surface quality as being rough, smooth, soft, etc. It can be actual or implied.

tooth the textural "feel" or a sheet of paper. Charcoal paper has more tooth than smooth paper needed for pen and ink.

traditional art any style of art that treats the subject matter in a natural (rather realistic) way. A style similar to those used for many years.

unity a principle of design that relates to the sense of oneness or wholeness in a work of art.

urban environment refers to your surroundings when you are in a town or city.

value an element of design that relates to the lightness and darkness of a color or shade.

vanishing point in perspective drawing, an imaginary point or points on the eye level, toward which parallel lines recede, and will eventually meet.

vertical upright and parallel to the sides of the paper.

visual environment everything that surrounds you; usually divided into two groupings: the *natural* environment (trees, flowers, water, sky, rocks, etc.) and the *manufactured* or *people-built* environment (buildings, roads, bridges, automobiles, schools, etc.).

wash a color of ink or watercolor that is diluted with water to make it lighter in value and more transparent.

wax resist a technique that makes use of the fact that water and wax do not mix. Watercolor paint is brushed over a wax drawing, remaining only where there is no wax.

white glue any of the poly-vinyl-acetate glues on the market, each having its own trade name (Wilhold, Elmers, Sobo, etc.).

Use a stencil and some overlapping images and go to work with the media. This one uses crayon, some tempera spatter and oil pastel on dark construction paper. Paul Revere Junior High School, Los Angeles.

INDEX

150

All the skills that the artist has gathered over years of experience are put to use in a powerful drawing. Seed of Love *(51 x 36) (129 x 91 cm), by Charles White is an ink drawing, but several tools and techniques are combined to communicate the artist's feelings and message. Collection of the Los Angeles County Museum of Art.*

ACKNOWLEDGMENTS

Putting together a book such as this is not a one-man job, by any stretch of the imagination. The author becomes a gatherer of information and filer of photographs that pour in from willing art educators across the land. Without such concerned help, editing this volume would be impossible. My sincere thanks to you all: Jim Burke, Marshall High School, Los Angeles; Allen Evry, Wheaton High School, Wheaton, Maryland; Grace Garcia, Hollywood High School, Hollywood, California; Joe Gatto, Granada Hills High School, Granada Hills, California; Gene Gill, Reseda High School, Reseda, California; George Horn, Art Supervisor, Baltimore City Schools, Baltimore, Maryland; Dave Kohl, Luther High School North, Chicago, Illinois; Helen Luitjens, Paul Revere Junior High School, Los Angeles; Thomas Nielsen, Birmingham High School, Van Nuys, California; Rene Parola, Marshall High School, Los Angeles; Al Porter, Instructional Specialist in Art, Los Angeles City Schools; Wes Soderberg, Kentridge High School, Kent, Washington; Vernice Stroud, Fremont High School, Los Angeles; Roland Sylwester, Lutheran High School, Los Angeles; Bill Tara, Los Angeles City Schools Special Scholarship Class; Ted Wessinger, Gardena High School, Gardena, California; Richard Wiegmann, Concordia Teachers College, Seward, Nebraska; Donald Williams, Instructional Adviser in Art, Los Angeles City Schools; Norma Wrege, Carver Junior High School, Los Angeles.

Several artists were very helpful and cooperative, wishing to share their talents with young people around the country. All are specially gifted and their work adds zest to the visual content of the book. My grateful thanks to: Paul R. Allen, Sam Clayberger, Arthur Geisert, Ralph Hulett, George James, Roger Kutz, Valerie Love, Joe Mugnaini, Greg Pickrel, Al Porter, Guenther Riess, Roland Sylwester, Tom Sylwester, Corinne West Hartley, Charles White, John M. White, Richard Wiegmann, and Robert E. Wood.

Museum and gallery directors were especially kind in helping me obtain materials which greatly enhance the book, especially in its historical content. My sincere thanks to: Margaret Anne Cullum of the Dallas Museum of Fine Arts, Texas; The Director of the Albertina Museum, Vienna, Austria; Ebria Feinblatt, the Los Angeles County Museum of Art; Bob Gino and Phil Orlando from the Orlando Gallery, Encino, California; Darryl Isley, The Norton Simon Museum of Art in Pasadena; Lynda B. Kershow, Boston Museum of Fine Arts; Wayne LaCom, the Emerson Gallery, Tarzana, California; Linda Loving and Richard Tooke, The Museum of Modern Art, New York; The Metropolitan Museum of Art, New York; Linn Orear, Fogg Art Museum, Harvard University, Cambridge; Joseph Young, Los Angeles County Museum of Art.

Thanks also to the following people and their companies for graciously allowing me to use some of their published material in the book: Moya Brennan and David Herbert of Studio Vista Limited, Publishers, London, England; Mrs. Jimmie Kromas of California Computer Products, Inc., Anaheim.

Special thanks to Al Porter who photographed some very special sketchbooks, to George Horn who pushed and inspired at the right moments, and to my wife Georgia, who put up with it all, and kept smiling.